Landscape Photography
A KODAK GUIDE

Cover photograph by Russell Lamb,
Russell Lamb Photography:
scilla blooming in forest in France.

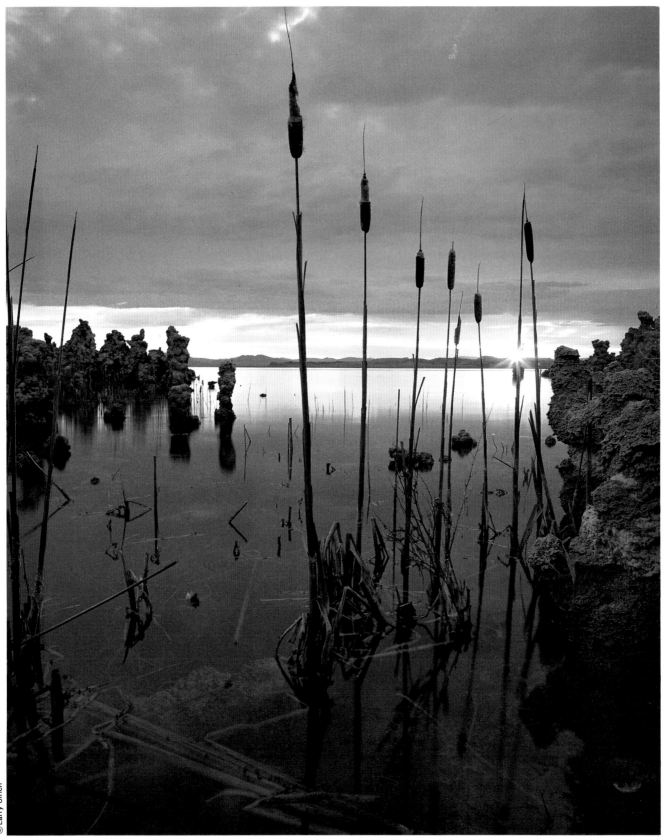

Landscape Photography

Written for Kodak by Jeff Wignall

McGraw-Hill Book Company

New York St. Louis San Francisco Bogotá Hamburg Madrid Milan Mexico
Panama Paris São Paulo Tokyo Auckland London New Delhi Singapore Sydney

The Kodak materials described in this book are available from those dealers normally supplying Kodak products. Other materials may be used, but equivalent results may not be obtained.

KODAK, KODACOLOR, T-MAX, TRI-X, PLUS-X, KODACHROME, EKTACHROME, VR, VR-G, and WRATTEN are trademarks.

Landscape Photography
Written for Kodak by Jeff Wignall

Editor: Derek Doeffinger
Book Designer: Dan Malczewski
Cover Design: Bill Sabia, ES&J
Typesetters: George Taenzer and Anna DeRubeis

Photographic Products Group
EASTMAN KODAK COMPANY
Rochester, New York 14650

Published in association with McGraw-Hill, Inc.
ISBN 0-07-070299-3
Library of Congress Cataloging-in-Publication Data

Wignall, Jeff.
 Landscape photography.

 Includes index.
 1. Photography—Landscapes. I. Eastman Kodak Company.
II. Title.
TR660.W49 1987 778.9′36 87-17079
ISBN 0-07-070299-3

Printed in the United States of America

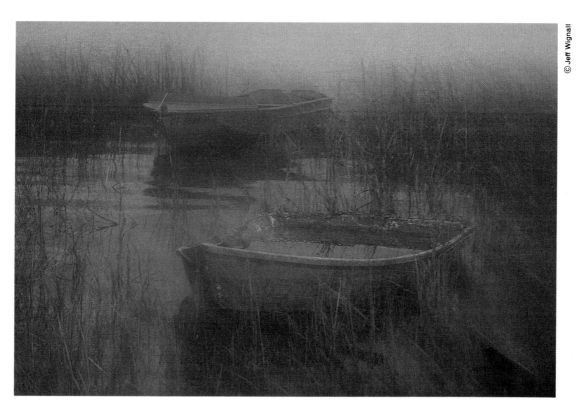

To instill a romantic mood to this midday photo of two skiffs, the photographer smeared a UV filter with petroleum jelly and attached it to the lens.

Introduction

To write this introduction, I have abandoned my office. The ringing of the telephone, the blinking of the cursor on the word processor, the droning of the television in the next room, the barking of the neighborhood dogs—all distracted from the task at hand.

I retreated. Fifteen minutes across town, through midday traffic jammed at intersections, past the shopping malls and aircraft factories, beyond the fast-food frenzy, to the most natural and serene spot I could find in these suburban wilds: a seawall at the edge of Long Island Sound. A cold November surf stroked the shore—not the blustery and boisterous surf of an ocean beach but a muted, rhythmic surf that hissed across the sands and occasionally threw a mist over the seawall.

This part of the Sound is on the Connecticut shore, near where the Housatonic River ends its flow. Divided from the Atlantic by a hilly, windswept Long Island, the Sound is but a toe of the Atlantic.

The Sound began as a river valley. Great inland rivers on their way to the sea carved out a coastal plain. Sediments from the rivers settled on a submerged shelf and formed the base upon which the hills and dunes of Long Island now sit. Later, great fields of ice plowing their way to the sea gouged the valley deeper. When the climate warmed, the ice melted and receded. The valley filled with meltwater. The Atlantic rose and severed the peninsula from the mainland. Long Island was born.

Land has a history. It is not what it was. Glaciers advance and retreat. Seas rise. Waves beat upon the land. Rains erode land particle by particle. Mountains thrust up only to be worn down. Continents edge apart. Earthquakes rip the planet's skin.

As you stroll across the land and set your camera on a tripod, you will attempt to capture in 1/60 second what has taken millions of years to evolve. To try and capture, perhaps make art, in a split second what took nature eons to make seems, if not arrogant, then improbable.

But it's also wonderful.

Contents

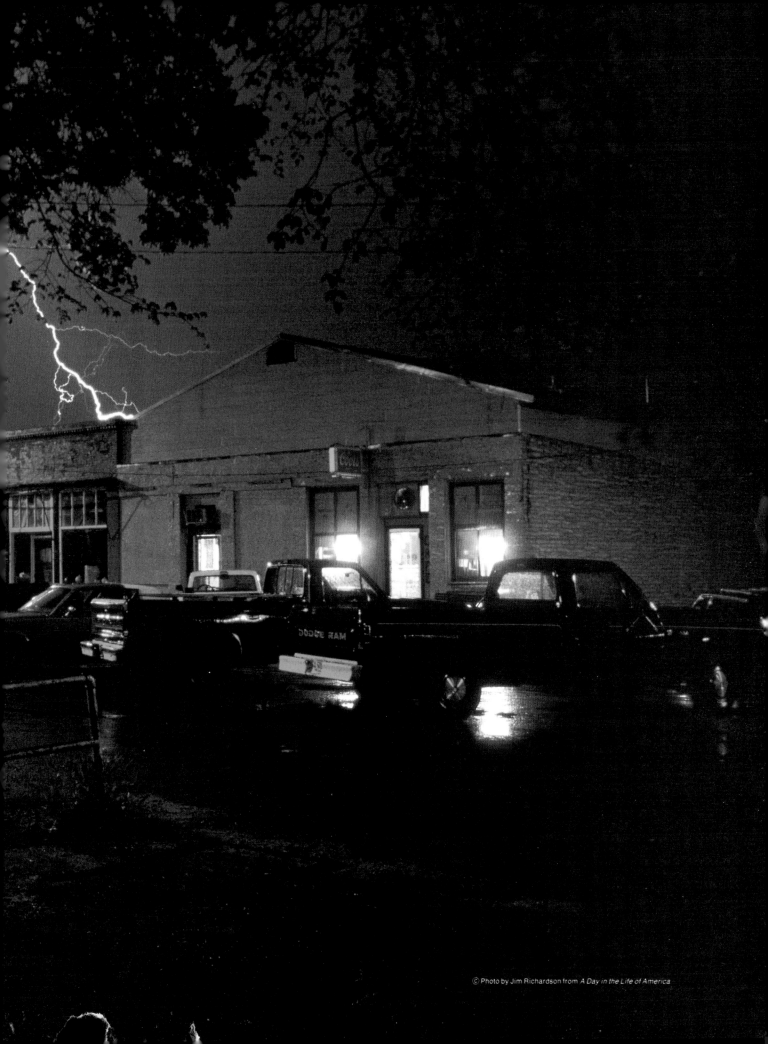

What is a Landscape?

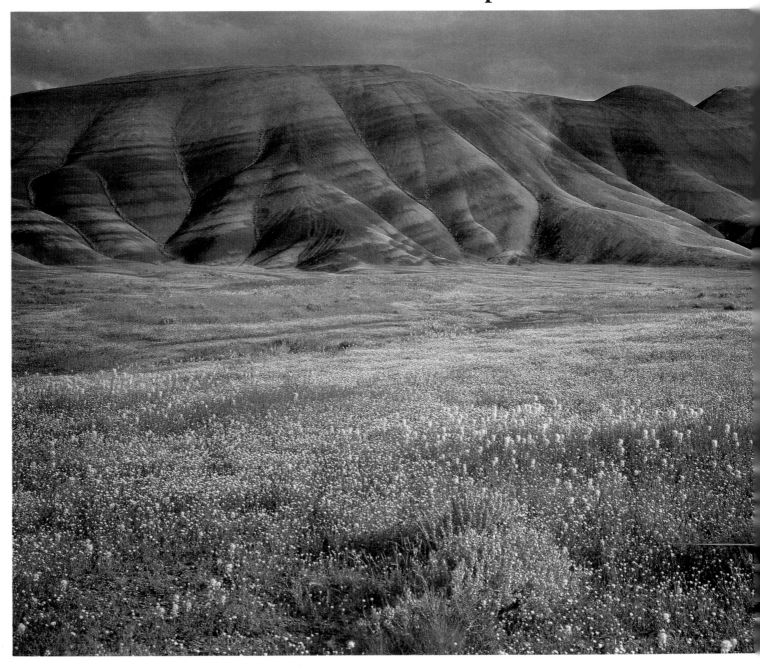

For many of us, the topic of landscape photography conjures associations with Ansel Adams' eloquent monochromatic vistas of the American Southwest or Edward Weston's timeless portraits of the California coast. Others find the term synonymous with the exotic scenic photographs that fill the pages of slick travel magazines or the colorful panoramas of nature in wall calendars that fill us with envy as we flip through the pages.

Although each of these are valid interpretations of the medium, they only begin to describe the variety of subjects available to the landscape photographer. And, as you will see, nature is not the sole supplier of inspiration for the landscape photographer. Nor does a landscape necessarily have to include land.

In the most literal sense, a landscape is a portrait of the land. But perhaps more accurately, a landscape can be defined as a photograph that describes a particular place at a particular instant, as seen through the eyes of an individual photographer. The photographer can interpret literally or metaphorically.

The places that a landscape photograph can describe are limitless. They can be natural or manmade, or a combination of the two. They can be as vast as an ocean or as intimate as a seashell. They can be as glamorous as the Las Vegas strip or as mundane as a parking lot. They can be as solid as the ground below your feet or as ethereal as the sky above your head.

Indeed, the subjects for landscape photography are so varied that you have to decide for yourself what constitutes a landscape. What should *you*

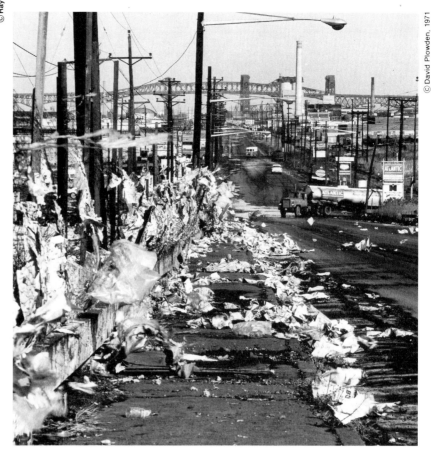

With the help of the wind, a roadside fence has netted a catch of litter. Grandeur and beauty are not the only subjects for landscape photography.

Rolling hills, gentle pastels, blossoming fields, breaking storm clouds: this scene embodies the dreamlike escape sought by many landscape photographers. The total harmony in this photo represents the grandeur and idyllic approach to nature photography. Painted Hills in John Day Fossil Beds National Monument, Oregon.

photograph? The biggest restrictions to finding interesting scenes are your own preconceptions, prejudices, and uncertainties about what a landscape photograph is supposed to look like (it isn't "pretty" enough or "unusual" enough). To the general public as well as many photographers, the scenic photographs in calendars and nature and travel magazines have come to represent the ideal of landscape photography. Admiring such photographs is inevitable; imitating them may be, too. But once you begin to explore landscape photography, you'll find no such thing as a characteristic landscape photograph.

Don't be restricted by tradition if traditional subjects and methods don't appeal to your sense of esthetics. Conversely, don't reject certain subjects—sunsets, for example—simply because they seem trite. Even the so-called trite subjects can be seen in fresh ways. No two people will ever see or approach the same subject in exactly the same way.

Photograph the places that capture your imagination, that mean something to you. Photography is an act of personal exploration. You seek to reaffirm or explore your identity in the places and subjects that you photograph. By photographing those places, those scenes and tableaus that make you gasp or chuckle or sneer or sing, you will define landscape photography in your own terms.

On the next few pages we'll look at some of the more common landscape subjects—and some not so common. We'll look, too, at some very familiar but often overlooked places.

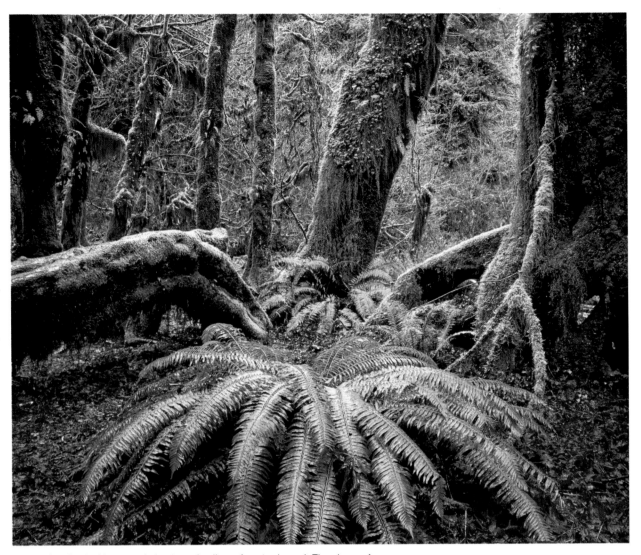

A large fern backed by moss-laden trees implies a forest primeval. The shape of
the fern offers a focal point, while the rest of the forest serves as a backdrop.

There is a mystique about the natural and wild places that makes them interesting subjects on both a visual and spiritual level. Successful natural landscape photographs capture not only the raw beauty of nature's special places but also the feelings of wonder and mystery they evoke.

You need not travel to exotic or distant locations to find beautiful natural landscapes. Beauty in a landscape photograph comes not from the uniqueness of the location but rather from the photographer's ability to reveal his vision of a place—whether it's a neighborhood meadow or a tropical rainforest.

Land, water, sky. These simple words stand for infinite variations. Since ancient Greece, man has recognized each as an elemental and vital part of his surroundings. For the landscape photographer, they are equally vital, for they are his subjects.

THE LAND

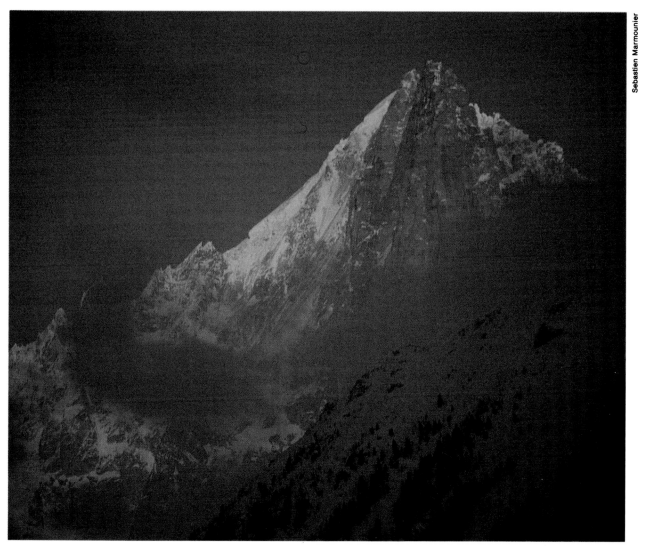

Stained a theatrical pink by the setting sun, this peak stands out against the twilight sky and the shadowed clouds and mountains in the foreground.

Mountains, plains, plateaus, canyons, kettles, ridges, valleys, boulders, dunes, crags, scree. Forests, beaches, meadows, deserts, hedgerows, shorelines. The variety of land is extraordinary. If you were to make a list of the different features within a few hour's drive of your home, the diversity of that list would surprise you. Extraordinary too are the perpetual changes in the mood and atmosphere of the land—changes caused by light, weather, seasons. Some changes are bold, others subtle. If you are unfamiliar with an area, study field guides and topographical maps to find hidden features. Drive the back roads to discover new places. Then explore by foot. for only through walking can you get the feel of a place. If you find interesting landscapes but the weather or lighting is not photogenic, don't give up. Make record shots of the scene that you can study later and use to prepare for better conditions.

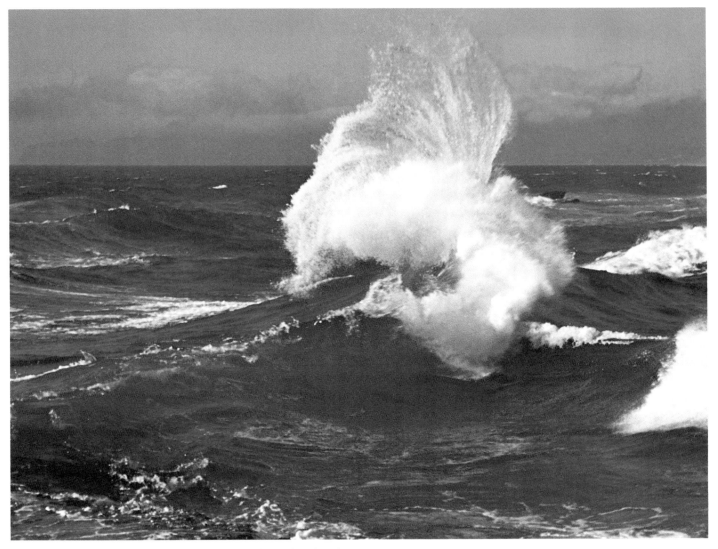

Snapping skyward, a wave culminates in a white plume frozen by a fast shutter speed. The variety of ocean and shore, of big rollers slamming into cliffs and lappers petering out at your feet, of haystacks on the Oregon coast and dunes at Cape Hatteras, gives you a chance to pick and choose your photos.

With its eternal rhythms and vastness, the sea possesses a special magic for many of us. Perhaps a vestigial tide within us still responds to its ebb and flow. How else could we sit for hours hypnotized by the waves slapping ashore, spellbound by the infinity of sky and sea sloping toward the horizon?

The sea provides many opportunities for photography as it interacts with the land. You can capture its power as it explodes into a rocky shore, its gentleness as it laps at a beach, its movement as it washes around kelp, or its brilliance as it throws back a thousandfold stars from the one overhead.

INLAND WATER

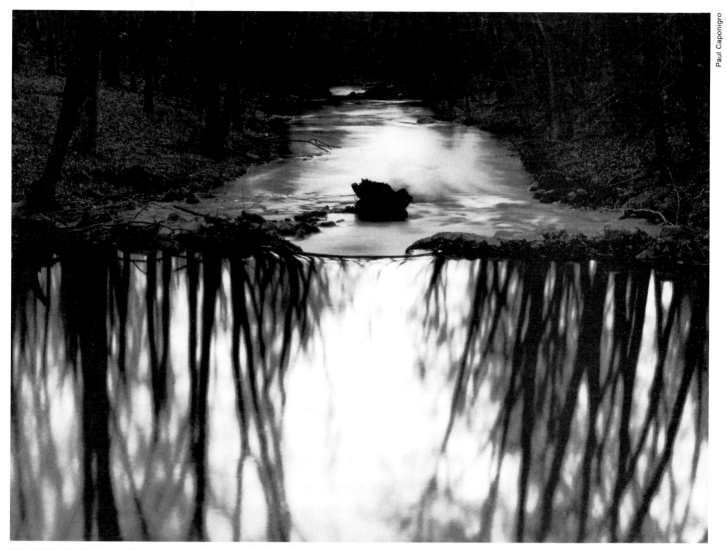

Paul Caponigro

Inland water is often tranquil: a stream gurgling through November woods; a frozen puddle waiting for a child's heel; a lake stilled by August heat.

Inland bodies of water, whether still or moving, are a delight to explore. Streams, rivers, lakes, ponds, waterfalls, and bogs exist in almost all corners of the country and probably in your neighborhood. Moving water often reflects the personality of its environment: a rippling trout stream speaks eloquently of a quiet wood, just as a cascading waterfall represents the ruggedness of a mountain glen. With moving water, look for the interaction between water and rocks or water and logs, as ripples, backwashes, and eddies curl around obstacles. With still waters, look for unusual reflections in the surface of pond or lake that tell the story of a larger scene—a mountain peak at sunrise reflected in a quiet pool, tree trunks upside down and shimmering as a light breeze ripples the water. And, don't neglect that most mundane and short-lived source of water—the puddle. Like an eye, it can stare or glimmer.

Ray Atkeson

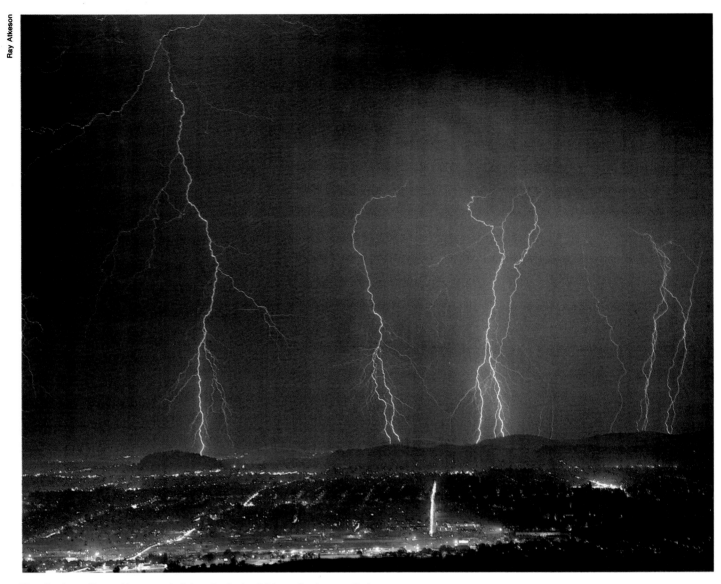

Thunderstorm. Dogs whimper and slink under beds, children cling to parent's legs, and adults stare out the window, jumping at the clap of thunder that was too close. A time exposure of several seconds was used for this photograph. (See page 77 for photographing thunderstorms).

Colorful, infinite, ever changing, and usually underlooked is the sky. Day and night, summer and winter, from rainbows to lightning, sunlight to starlight, from cumulonimbus to cirrostratus and mare's tails to thunderheads, the sky is an aerial parade. Whether you use it as a subject unto itself or include land or water, it's there for all to photograph.

The great photographer Alfred Stieglitz enjoyed a lifelong fascination with clouds. In 1922, after many years in photography, he began an ambitious project of cloud photography, explaining:

I wanted to photograph clouds to find out what I had learned in forty years about photography. Through clouds to put down my philosophy of life—to show that my photographs were not due to subject matter—not to special trees, or faces, or interiors, to special privileges, clouds were there for everyone—no tax as yet on them—free.

14

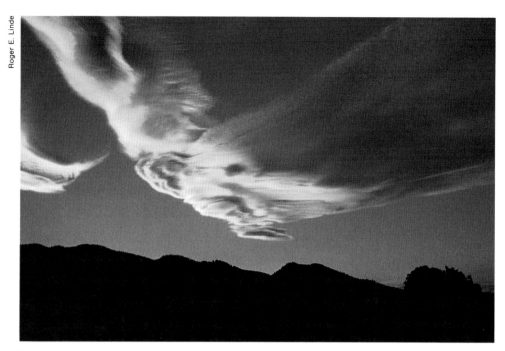

Ever changing and ever present, most of us ignore the sky, except at sunrise and sunset. Yet its clouds can be feathery delicate or massively imposing. Even the gray clouds of an overcast day can contribute to a photograph.

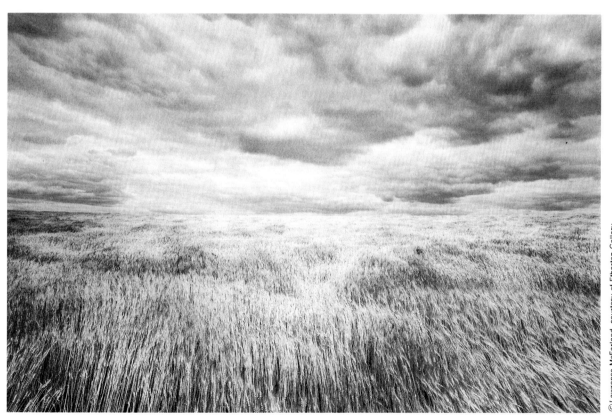

By using the similar tones of wheat and sky, and by placing the horizon across the middle so that the sky and field rush towards the center, the photographer thrusts us into a photographic vortex.

Don Wilson

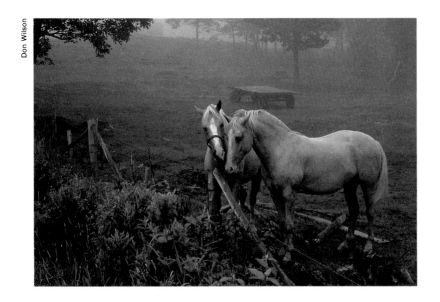

Spraugue E. Plato

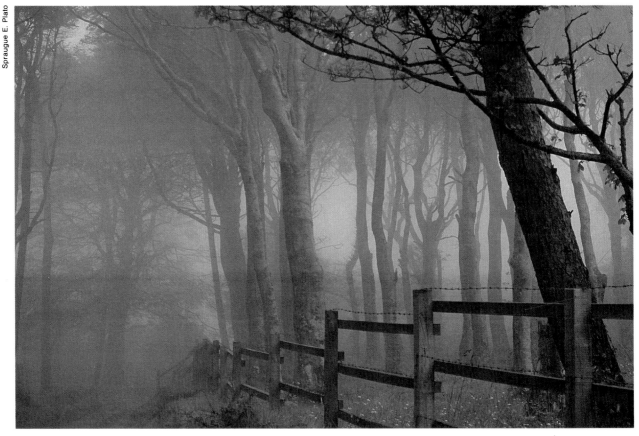

Resplendent with silence and serenity, fog veils rural scenes with romance and intimacy.

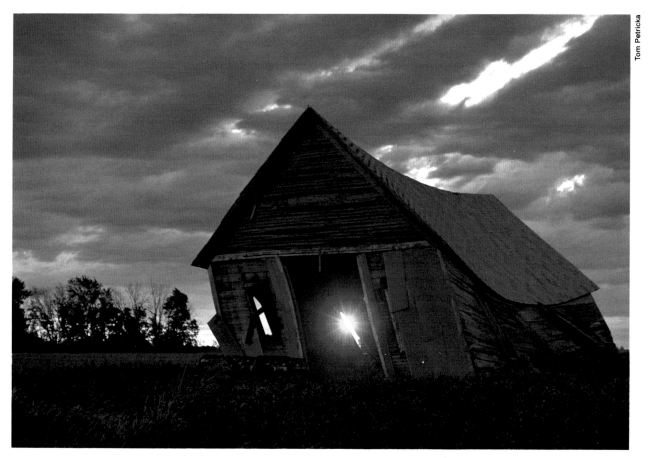

Tom Petricka

Bowing like a spinnaker, this sagging barn verges on collapse. But the fireball of the sun seems to radiate a physical energy that supports it.

Far from the throb and jangle of city life, rural places display a quieter and more pastoral side of our human environment. Winding country lanes lined with stone walls, village greens ringed with fine colonial homes, and picture-perfect farms surrounded by rolling hills—few of us tire of seeing such pictures. And few photographers tire of shooting them.

Rural scenes relax us. Just to see a pasture of cows or a weather-worn barn by a sea of corn fields reminds us that calmer, more sane places still exist. Farms and country villages also tend to have a built-in sense of order that lends itself to photography. In fact, some rural places have a visual esthetic so picturesque they seem to have been designed by art directors for the enjoyment of wandering photographers. And those who find such scenes cloying can turn to the less cared for farms, where dilapidation encourages artful as well as ironic interpretations. Unlike city structures, defiled by and succumbing to vandalism, sagging barns and listing chicken coops seem to be naturally yielding to the forces of nature. Their decline is graceful. Their aesthetic irresistible.

Between the urban and rural worlds, there lies the great middle ground—suburbia. Backyards and schoolyards, neighborhood parks and shopping malls, suburbia is home to many of us. And yet, for all of its familiarity, few of us ever give it a second glance. If familiarity breeds contempt in relationships, in photography it breeds invisibility.

How often have you walked around your neighborhood and shot the sideyards and hedgerows that were so mysterious and wonderful when you were a child? Have you ever knelt in the garden and photographed the tomato plants in the morning light? Have you paid homage to that backyard icon, the garden shed? Or that symbol of summer—the garage sale? McDonald's, Arby's, Wendy's, Burger King, from all we receive a downpour of jingles and from one you likely receive regular dispensations, but have you considered their place in the local landscape?

As children, we were able to fantasize in the simple surroundings of suburbia. As adults we ignore them. To the basements of our imagination we dismiss the sheds and driveways, favoring instead jaunts to flashier locales—the waterfalls and nature preserves within driving distance of any city. Perhaps we've become too jaded to notice the potential of the ordinary places or maybe too lazy to look. But by re-exploring them, we may rediscover the singularity of the suburb.

A suburb consists of enough similar houses, similar lots, and even similar trees to make a pattern. Its culture is conformity. But within that conformity abound nuances (rose gardens, naturalized yards, junk cars) that comprise the largely undocumented suburban landscape.

© Robert Llewellyn

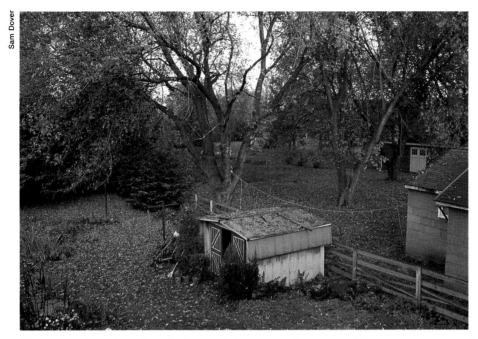

Above, pervasive and mundane, the backyard shed, as seen from a second-floor window on an autumn day, relays feelings of comfort and familiarity. By making a photographic study of your yard and neighborhood, you might surprise yourself as to how photogenic your neighborhood is. **Below,** here is the photographer's home street photographed with a 300 mm lens to compress the distance between the trees.

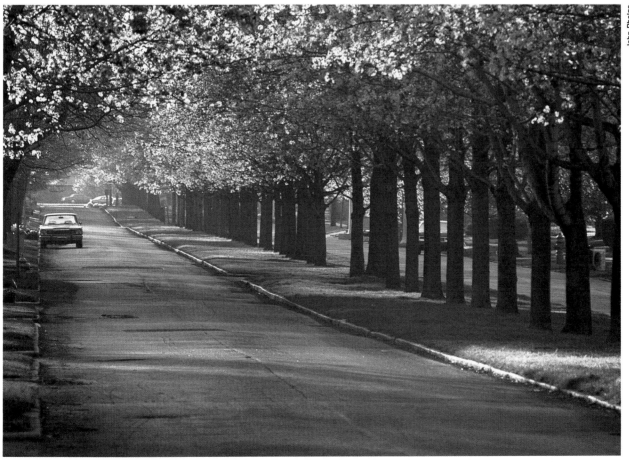

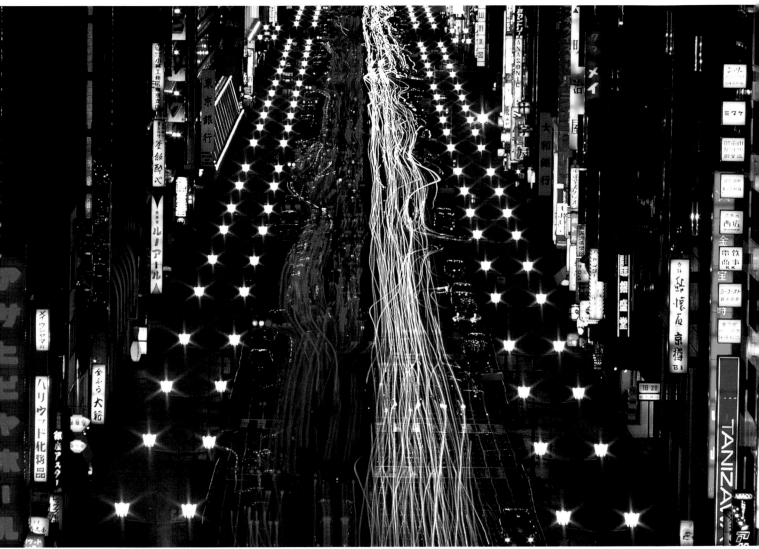

At night a city becomes its lights. Harald Sund used a 135 mm lens set at f/5.6 and KODACHROME 64 Film to photograph the Ginza in Tokyo. The long exposure (3½ minutes) caused the lights of moving cars to form the streaks down the middle of the photograph. Sund wanted to show ''colorful motion'' by contrasting the wiggly lines of the car lights with the fixed shop lights.

Sometimes dismal, often glamorous, cities are carnivals of shape and color, light and life. And like different types of natural environments, different cities have personalities uniquely their own. In older cities, gargoyles stare down at cobble-stone streets, and Victorian houses in disrepair struggle to retain dignity. In younger cities, towers of glass surrounded by condos flare into the sky to escape a snarl of concrete highways. In a period of transition, many cities show an intriguing mix of old and new.

Because of the inherent patterns and regularity of shapes in manmade structures, cityscapes are sometimes easier to compose than natural landscapes—they are simply more organized, less random. Lines, shapes and forms abound in the buildings, in the spaces that surround them, and in the design of the city itself.

Like natural landscapes, cities are readily enhanced or embellished by changes of lighting or weather. The first light of dawn raking across the empty sidewalks of Manhattan, the evening fog rolling over the rooftops of San Francisco, or a fresh snow decorating the streets of Boston—each happening adds atmosphere and exemplifies the character of a city.

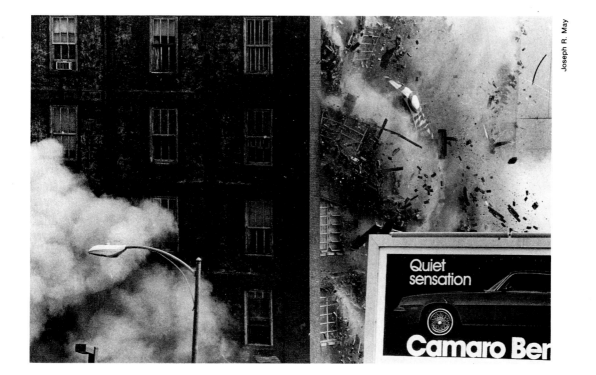

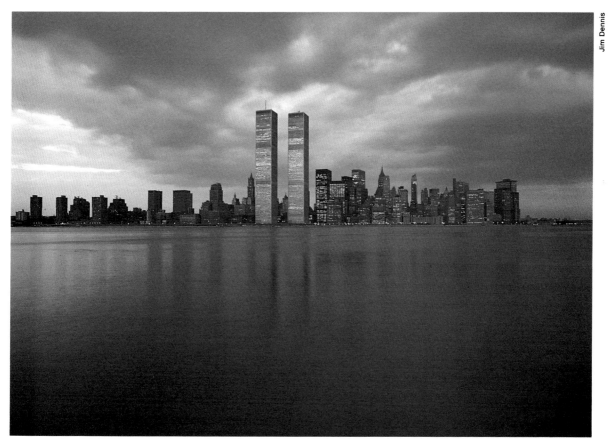

Top photo, if advertising weren't known for occasional hyperbole, the humor of this picture might not seem so appropriate. Any city is rife with such visual humor. You need only carefully arrange the contrasting elements so that they clearly interact with each other. **Bottom photo,** poised above placid waters and beneath serene skies, this Manhattan skyline seems bereft of horns blaring, feet stomping, and wheels squealing.

Reading the Land

As a landscape photographer, your greatest tool is your ability to read the land and relate its story. You must learn to conjure the drama of shadow and light, of rock and stream, of cliff and sky; to convey the serenity of sand and shore, of path and woods; to reveal the irony of man and wilderness. You must learn to see what is before you and comprehend what is behind you.

Like all photographs, a landscape photograph begins with seeing. Sometimes seeing a landscape is a conscious effort: You're in the field, camera in hand, searching for that special arrangement of elements that says "spring" and you find it—a beautiful dogwood tree at the peak of its bloom. Other times seeing is accidental: You are driving to the grocery store when a familiar scene of benches in a park unexpectedly snatches your attention and pulls you to the side of the road.

In either case, your photographer's instinct has responded. From this point, capturing the scene before you would seem to be a straightforward transaction. Frame, focus, take a meter reading, and shoot. Once you've identified your subject, seemingly the job of *seeing* is over. Or so you think, until the photos are processed and your brilliant dogwood is lost in its surroundings and the lawn chairs look—well, like lawn chairs.

The problem is that you haven't understood why the scene appeals to you. Or if you have understood its appeal, you've been unable to capture that appeal photographically. Finding a subject is only the start of the larger visual process of seeing. It's an important beginning, to be sure, since an awareness of your surroundings is the beginning of photographic vision, an awakening of emotional response. But before you can translate your vision into a compelling photograph you must evaluate the scene for its visual qualities and determine if those visual qualities can carry your vision.

Why did you notice that tree? What about it excited you? Was it the early morning sun backlighting the leaves and blossoms? Or was it the symmetrical pattern of its limbs? Why did you choose that tree and pass by others? Whatever it was, pin it down and decide if it will work in a photograph.

Dissecting a scene into its various visual components and measuring your response to each of them may sound like a painfully analytic approach to seeing—particularly while your imagination is still under the spell of the scene. However, once you've pinpointed a scene's attraction, you can strip away the fat of a scene so that only the meat remains.

Initially, the time lost making such a careful and detailed analysis robs some spontaneity. Fortunately landscapes usually afford you the time. And eventually, as you gain experience, the process will become an instinctive and integral part of your photography.

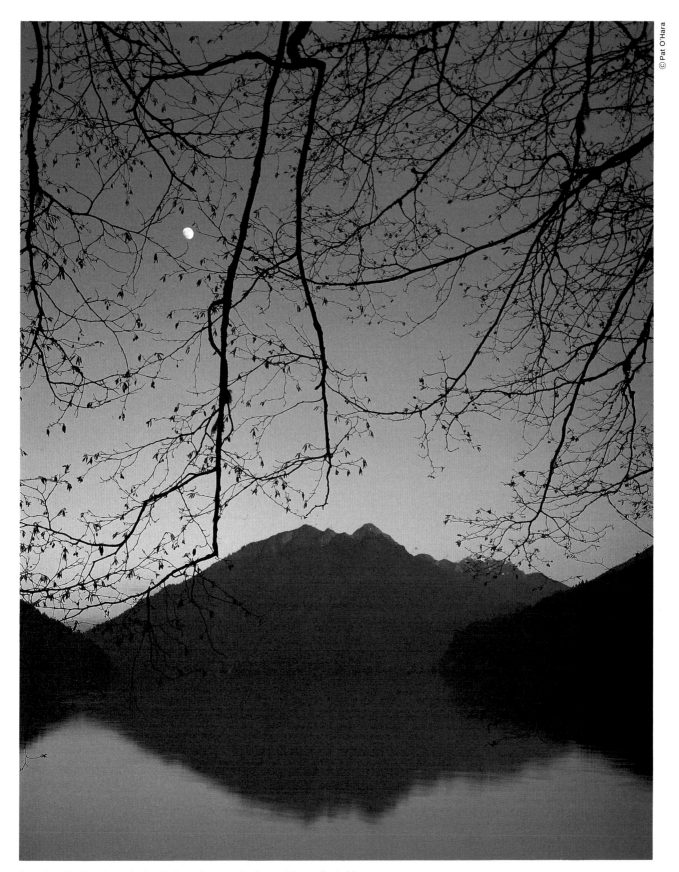

Contained in this picture is the obvious photograph of mountains reflected in a lake. But photographer Pat O'Hara stepped beyond the obvious reflection picture. By snaring the moon and mountains with a lacy net of overhead branches, he instilled a delicacy that's absent in the mountains themselves.

The camera captures everything within its field of view (when a small aperture is used). Although the photographer noticed the clutter when taking this picture, even he was surprised at how much showed up in the photo.

EYE TO CAMERA

The image of a scene formed in your mind and that caught by the camera and by the film differ. Some of the differences are substantial, some slight. The trick is to visualize how these differences will affect the image before it's made, and to take them into account when planning the photograph.

Let's begin with the way your eyes look at a scene. Upon finding an interesting scene, your eyes dart about, investigating textures, squinting at a highlight here, penetrating a shadow there. They scan the scene, passing along information to the brain, which pieces these glimpses into a coherent image.

By concentrating on the important parts of a scene (with or without your conscious aid), your eyes and brain eliminate the distractions and clutter to paint a mental picture to match your mood or your expectations. Enamored of the sunset, you ignore the smokestacks at the horizon. Awed by the waterfall, you overlook the styrofoam cups floating in the stream.

Not only do your eyes tend to select what is important to them, they also tend to wander and see things beyond the camera's view, things that may later mislead you about the scene in the viewfinder. With your camera pointed at driftwood on the beach,

you may glance overhead and see a string of delicate Cirrus clouds or look to the left and watch the waves washing over a jellyfish. These images will linger in your mind. They will exert their influence even when you return to looking through the viewfinder at the driftwood. As you build the picture, resist the influences outside the borders of the viewfinder. They are palpable while you are at the scene; they are gone by the time you are viewing the photograph.

A camera sees only what you point it at. It is confined to the area in the rectangular viewfinder. Its focus is set by you. Its viewpoint is set by you. It sees everything at which it is pointed. It sees nothing beyond the viewing angle of the lens. It cannot ignore what is before it. It cannot be impressed by what is beyond it. It has no urge to hitch its pants or swat a fly. Nothing distracts it. So be sure you are seeing all that is there in the viewfinder. And then be sure that what you are seeing is what you want.

Nor is the camera distracted by physical and emotional concerns. Nothing distracts it. Not so with you. Driven by the logic or emotion of the brain, which is often not solely attuned to photography, you may not be fully attending to the scene. Can

the brain concentrate on photography when the stomach rumbles rebellion or the back torments the sciatic or your conscience harps about the windows that need glazing? Not likely.

Film too has its biases and its limitations. Black-and-white film, of course, sees only in shades of gray and is in many respects color blind—unable to completely distinguish between reds and greens, for example. Color films may emphasize color at the expense of other elements of the scene. And no film can match your eye in its ability to distinguish a wide tonal range, from deep shadow to bright highlight. However, negative films, such as KODACOLOR VR-G 100, have greater tonal range than slide films.

With so much technological and psychological distance between your original excitement at finding a subject and the final photographic image, it's easy to see how your creative vision might get lost in the shuffle—a victim of the very medium used to capture it. But once you understand and anticipate each step of the process and incorporate your knowledge into the seeing process, you'll gain a new level of control over the photographic process.

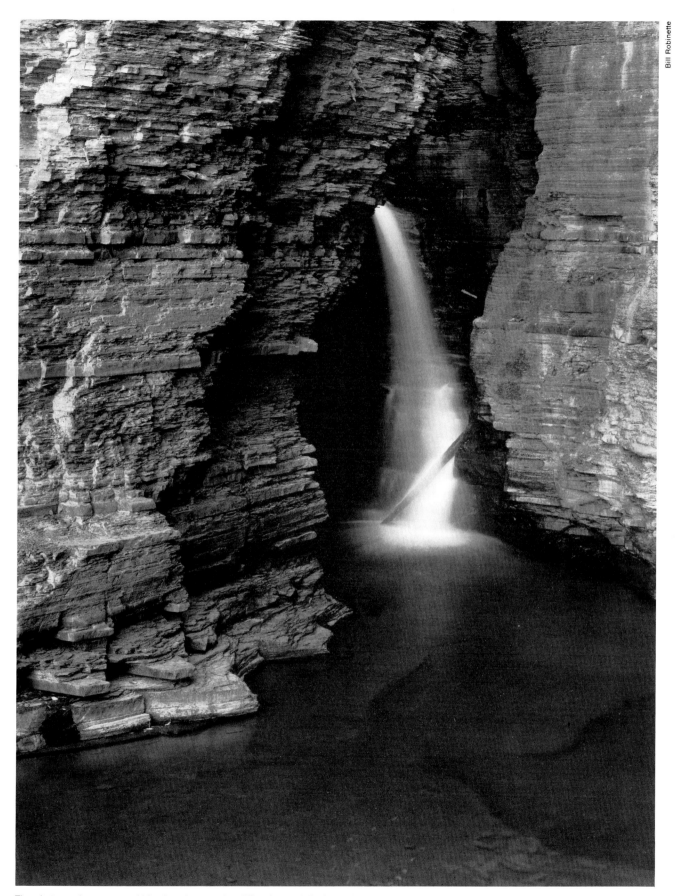

The photographer narrowed his view down to the cliff and waterfall. He then used a long shutter speed (1 minute) to blur the water so that it looked more like a spray of light than water.

SIMPLICITY VS. COMPLEXITY

How much should you include in a photo? Only enough to make your point. Too much information can bewilder, particularly if it offers no clear point of view. Too little can leave the viewer unsatisfied, thirsting for clues.

Many photographic texts advise that simplicity is sacrosanct, that complexity is a treacherous sea never to be ventured upon. But the world is full of complex places—beautiful in their intricacy, fascinating in their elaborateness. Places interwoven with textures and shapes and forms, rife with tangled layers of vegetation and unexpected clashes of terrain, pleasure the eye. Busy city streets whirl in a dizzying disarray of motion and color; industrial compounds confound the imagination with curious and alien labyrinths of technology.

To simplify such complexities purely for the sake of simplification would be to rob them of their character, to strip away the visual excitement that attracted your attention at the start. Deleting too much information destroys the context of a scene: A fleet of taxis cruising a city street could be anywhere, but back up and show the scintillation of a hundred neon marquees and the location is instantly identified as Times Square. Show the marquees without the traffic and you lose the human dimension of the scene.

Often a complex scene is rich with minute detail. To reveal this detail, use a fine-grained film, such as KODACOLOR VR-G 100 or KODAK T-MAX 100 Professional Film. Even for a more simple scene, you should consider using a fine-grained film, because the uniform areas of sky and water common to simple scenes can exaggerate the appearance of grain.

There are, of course, valid arguments regarding the virtues of simplicity. Simple compositions speak directly and powerfully, with no wasted visual ingredients. They leave little room for misinterpretation. Frequently, isolating a single visual element better relates the essence of a scene than a broader, more comprehensive view. A single rose says as much about the beauty and grace of spring as a garden full of rosebushes. Its very intimacy reflects the delicacy of nature.

Which interpretation is correct? It depends on the subject and the intent of the photographer. If a scene loses its glamour or interest by reducing its complexity, it's obvious that complexity fueled it. On the other hand, if meaning gets lost by including too many elements, re-examine your approach and see which elements are only dead weight.

Clarity of vision and adherence to a central unifying theme, whether you're photographing one element or a dozen, define your composition. Complexity without a singular viewpoint is confusion. Simplicity without substance is superficial.

Opposite top, simple scenes are often eloquent. This scene includes but a segment of a stream and its snow-covered banks. The small reflection of pink clouds in the upper part of the stream offsets the monochromatic quality.

Opposite bottom, the knife-edged mud hills of Death Valley provide a wealth of details, shapes, shadows, and forms that challenge the photographer to provide a cohesive image.

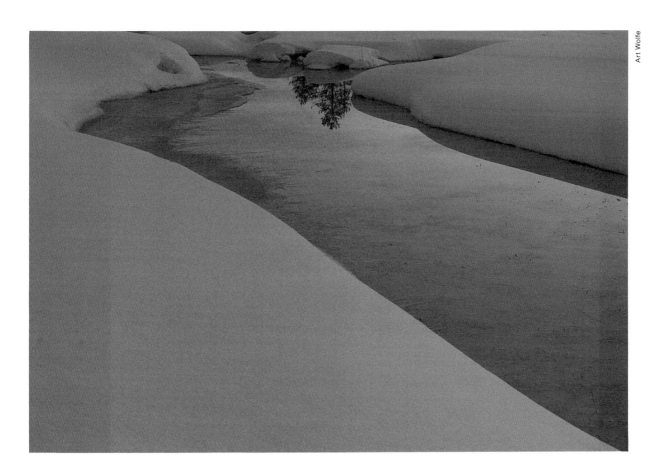

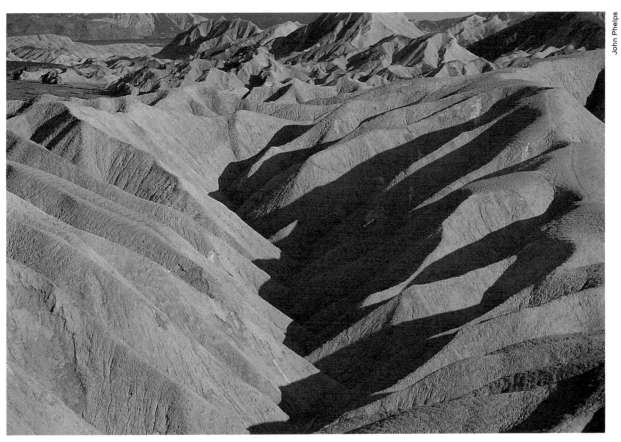

VISUAL CONTRASTS

As your eyes explore the world, they often pause first at contrasts. Contrasts excite and intrigue the eye because they add visual tension and suspense to a scene. Contrasts work by showing two opposing aspects of an element side-by-side: dark against light, colorful against pallid, smooth against coarse, or even sharp against unsharp.

In a photograph, contrasts can be used to create drama, to accent or isolate a particular element within a scene, to establish mood, or to organize and simplify more complex scenes. Sometimes they can be successful as subjects in themselves—as patterns or designs.

As you compose and arrange the physical elements of a scene, be alert to the different visual contrasts that exist. Unless carefully planned for, contrasts can become a source of distraction rather than a thoughtful embellishment.

Shown on the next few pages are several types of visual contrast.

Tonal Contrasts

An outdoor scene that contains an even transition of brightnesses from the darkest areas to the lightest is rarely as exciting as one in which some middle tones have been eliminated or reduced in size, leaving the dark and light tones to compete with each other. Bold contrasts create drama and vitality. Such contrasts usually occur when a scene is harshly lit (creating deep shadows), or when there are alternating areas of exceptionally light or dark subject material. Early and late in the day are the best times to look for contrasts, when the sun's rays are low and shadows long.

In black-and-white photos, tonal contrasts tend to produce a very graphic effect; in color photos, they intensify the apparent brightness of hues. In either case tonal contrasts are most effective with simple compositions that contain definite patterns of dark and light. When you find a tonal contrast that interests you, work quickly. Tonal relationships are often fleeting, dissolving as the lighting changes. In black and white, increase or decrease contrast with colored filters.

Silhouettes

The ultimate in tonal contrast is the silhouette. Shapely, mysterious, arresting in its simplicity, a silhouette describes the contour of a subject in perfection while leaving surface detail to the imagination. A silhouette occurs whenever a dimly lit subject is positioned between the camera and a brightly lit background.

Because the contrast range of such backlit scenes exceeds the film's ability to record, exposing for the brightness of the background will usually cast the foreground into blackness. To make the most appealing silhouettes, use colorful backgrounds—sunlit cliffs, brick buildings, a sunset sky. Interesting patterns or textures in the background also increase the lure of a scene.

The key to finding silhouettes is viewpoint. By exploring a subject from various angles you can often find a silhouette that isn't obvious at first glance. Climb a small dune, for example, to silhouette strollers on the beach against the brightly lit sand or the sea itself. In framing a silhouette, be careful that no extraneous shapes unintentionally interrupt the outline of your subject.

Opposite top, the contrast here is unmistakable. Sunlit aspens stand ever more brilliant because they are backed by a shadowed mountain. **Opposite bottom,** to make a silhouette, base exposure on the bright background. In this photo, the darkened foreground and the varying shapes of pine trees form a motif of triangles. The steep incline of the terrain and the bright quarter moon add variety.

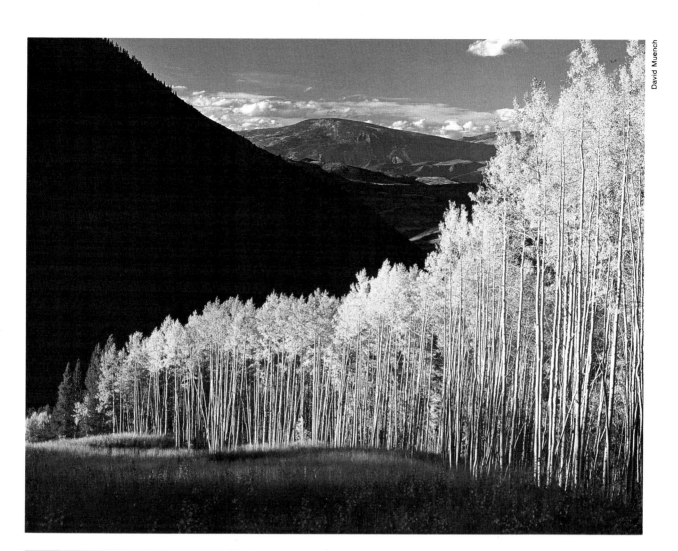

David Muench

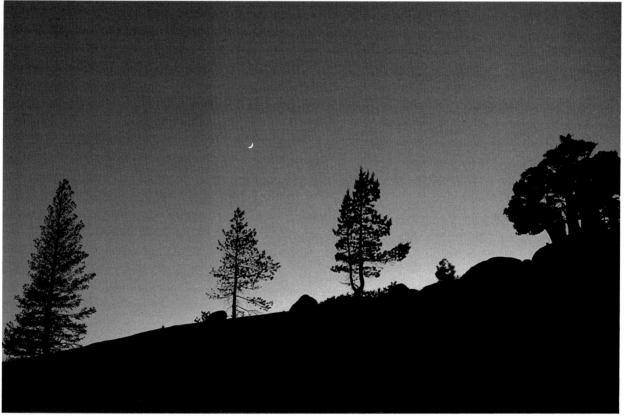

John Greene

Sam Dover

The small but bright and contrasting color of the sunflower enlivens this backyard landscape.

If bolstered by other elements in the scene, a monochromatic (single dominant color) scene is usually quite moody. A derelict and dilapidated house and a full moon create the moodiness of this twilight landscape.

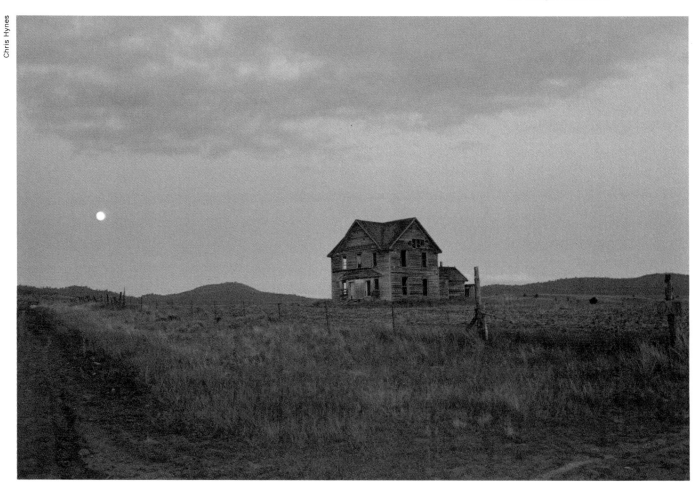

Chris Hynes

Color Contrasts

Vibrant, alluring, discordant—color contrasts offer many possibilities. Bright bold colors (especially the primaries—red, blue, green) played against each other grab the eye and, if arranged into a design, make an appealing photograph. If there is a subject other than the colors, the colors may distract from that subject. Though unintended, they may dominate and become the subject. And

rather than pulling the eye into the scene, such compositions tend to remain locked at the surface, lacking any illusion of depth. Conversely, brightly colored subjects photographed against a more sedately colored background appear to leap from the frame, heightening the perceived depth. If using slide film, you can increase color saturation by slight underexposure (about ½ stop). With

negative films, use normal exposure.

Unlike contrast that stimulates the visual system, the harmony of two or more soft or muted colors soothes the viewer. Where there is very little tonal distinction (approximately same brightness) between main subject and background (on overcast days, for example), color contrasts are effective in providing the visual emphasis necessary to separate subject and background.

30

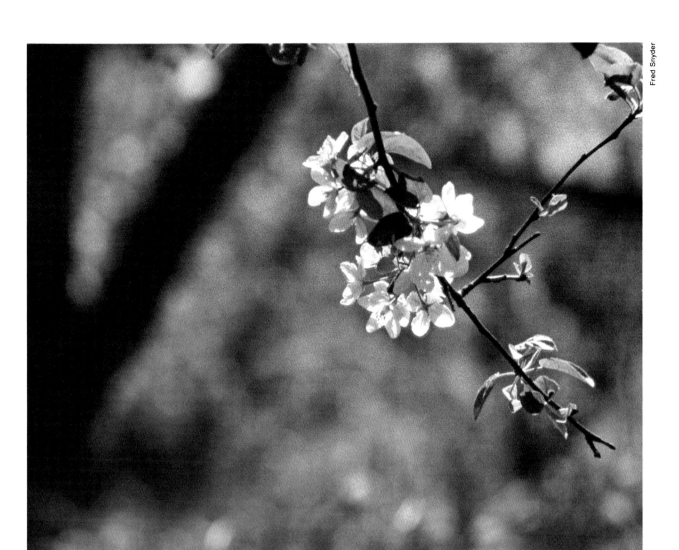

Fred Snyder

A sharply focused subject in front of an out-of-focus area directs attention to the subject. A 200 mm lens set at f/3.5 and KODACOLOR VR 400 Film were used to photograph this branch of apple blossoms.

Selective Focus

A visual contrast unique to photography is selective focus. It uses minimum depth of field to contrast areas of sharp focus against areas of unsharp focus. Because our visual system pieces together a scene, we tend to perceive everything as being equally sharp. Lenses, on the other hand, can restrict the region of sharpness, allowing you to isolate a birch tree, an ocean wave, or a blossom.

To avoid confusion about which parts of the scene are meant to be in focus, carefully choose the point of

focus for the subject. Since SLR viewfinders normally show you the scene using the lens' largest aperture (which provides the least amount of depth of field), you can analyze the selective focus just by examining the subject through the viewfinder. If the lens aperture is smaller than wide open, test the actual zone of sharpness with the depth of field preview button as you compose the scene. Achieving selective focus is generally easiest with telephoto lenses, nearby subjects, and large apertures such as f/2.8. Focus

carefully, especially when working with telephoto lenses, since the depth of field will be small.

Obtaining correct exposure in bright light with a large aperture may require a shutter speed beyond your camera's capability. To be sure of obtaining correct exposure, either use a slow- or medium-speed film, such as KODACOLOR VR-G 100, or use a polarizing filter to cut back some light. With color negative film, you can overexpose a few stops and still get good results.

SELECTING A VIEWPOINT

Next to deciding what to photograph, deciding where to photograph it from is the most important choice you'll face in planning a landscape photograph. No other decisions, no camera controls, no techniques will have a greater impact than viewpoint. Virtually all of a photograph's spatial, physical, and contextual relationships, as well as a large part of its atmosphere, result from camera placement. And yet, many photographers ignore the importance and potential of viewpoint.

Photographer Fred Picker writes:

Precise camera positioning is vital to the design of any photograph. Once the camera is in position, anyone can make the picture. Knowing this, I am constantly amazed that so few photographers give camera positioning anything more than the most casual attention. Many routinely set up on a nice convenient flat spot without regard to anything except their own convenience!

Often photographers rely on their first impression of a scene when choosing a viewpoint, without making any effort to look for better or more insightful approaches. But settling for a first impression is like ordering the first meal listed on a menu simply because it's the first thing you saw—it may be tolerable, but the odds of it being exactly what you want are slim. In scenic situations, first impressions frequently overwhelm the senses, diminishing your ability to make sound visual judgments.

Moreover, first impressions often result from common and predictable vantage points. We look up at trees, down at rivers, and across fields. Don't be so predictable. Explore your subject. Ignore the familiar and look for the viewpoint that brings your subject to life. Refine your first impression to reveal the harmonies and nuances that give substance to your subject. The only correct view of a subject is the one that works.

If your subject is nearby, circle it and see how the spaces between objects expand and contract as you change position. Watch as the visual tension between lines and shapes intensifies and then slackens. See how objects swell with volume and then flatten to a two-dimensional shape. See how the shifting direction of light changes the appearance and mood of the subject.

Inch closer to your subject and then back away to see how the size of nearby objects changes in relation to the background. More distant subjects, such as mountains or city skylines, may require you to drive to various vantage points over a period of days to find the best one. The more effort you put into establishing the best point of view, the better your photograph will be.

Experiment too with changes in the vertical point of view. Vertical shifts of only a few feet can have a surprising effect on your perceptions of a scene. Climb onto a tree stump or a stone wall and see how the surface of the land unfolds, enhancing depth and downplaying background. Lie on the ground and see low-lying objects suddenly soar above and watch mid-ground objects disappear. Ansel Adams frequently used a car-top platform to gain a few extra feet of height. Fred Picker once dug a two-foot hole in the ground to find the best angle for photographing a church.

Practice experimenting with viewpoint until it becomes a part of your photographic consciousness.

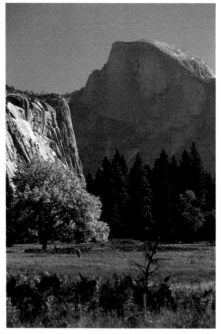

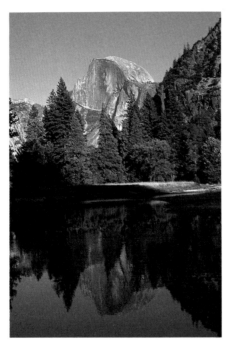

Changing your viewpoint may be as simple as stooping to emphasize the massiveness of a small boulder. But for large land features, such as Half Dome, you could hike many miles over several days searching for different viewpoints.

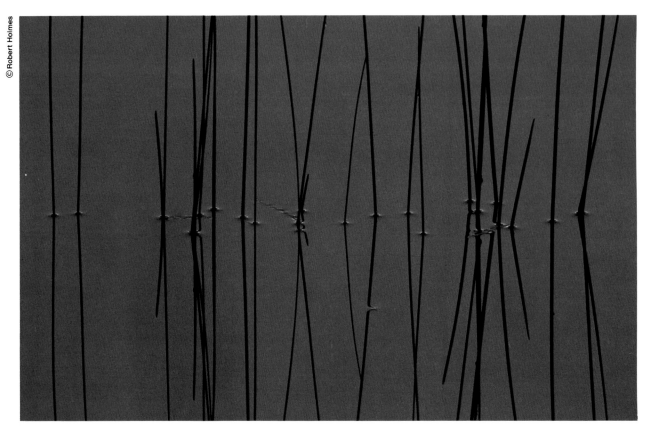

Lassen Volcanic National Park wasn't made into a national park because of its spectacular reeds. But by looking beyond the obvious scenery, the photographer was able to make an exceptional photograph.

DEALING WITH THE SPECTACULAR

Snow-capped peaks jutting into the blue infinity, flaming autumn leaves rustling above house-size boulders, roaring waterfalls plunging past cliff faces: These are the landscapes that have been photographed almost from the day that silver halide was mixed with egg whites and coated onto glass plates. These are the meccas to which photographers pilgrimage. And these are the places that are being repeatedly photographed even as you step into them.

Although the clicks of firing cameras may sound like a locust plague, like all the others before you, you too will feel the need to add your own interpretation. Even the most jaded and urbane of photographers find it difficult to resist the grand and dramatic landscape.

Approach these wondrous places realistically, even cynically. Through no fault of their own, they have become the superstars of landscape, and as such they suffer from overexposure. The places will seem familiar, even if you've never before visited them. For you will have seen countless pictures of them in calendars and magazines and as the locations for

television shows. The published pictures will have been extremely well done, because so many professionals photograph these places that some of them inevitably strike the vein of light and land that makes a rich ore. Once at the scene, do expect to be awed, for it will be spectacular. But don't expect your camera to be easily impressed.

As you prepare to photograph a natural wonder, study it carefully. Don't let it overwhelm you. And be aware that it will probably be foreign to your esthetic sense. If you have lived in a place of quiet scenery, you will have become attuned to subtle beauty. Thousand-foot waterfalls, fifteen thousand-foot mountains, and mile-deep canyons tend to boggle the minds of flatlanders and suburbanites.

Unless you've chanced upon a lucky coincidence or can stay there for days, you'll not get the dramatic lighting or weather needed to make a special picture. Instead you will have to work extra hard looking for the context or composition that makes your picture different.

Once you've made the obligatory photographs of the spectacle, review

the scene for its understated beauty. More than sensational cliffs and waterfalls stand before you. And with your juices flowing and your photographic eye warmed up, you may find you are well attuned to the subtleness that accompanies the spectacular. Scan the area with a telephoto lens. Isolate the fall pool. See how the cascade plunges into the stream. Or isolate the falls midway up as it drops past the cliff face or a leafy branch. Study the forest floor for pleasing arrangements of pine needles and aspen leaves. If you're at a national park, then you've got company. Study the other photographers in relation to the scene. Try to incorporate them in a humorous or ironic or even picturesque manner.

Don't overdo it trying to be original or your pictures may come out looking forced and contrived. At these places, you are likely the millionth visitor and your photos are the umpteenth millionth photos taken. That's not to say you can't come up with some classic shots, but you may be discouraged to find that in the scenery about you the cameras outnumber the trees.

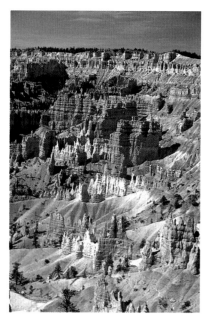

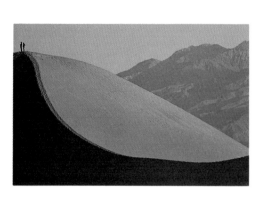

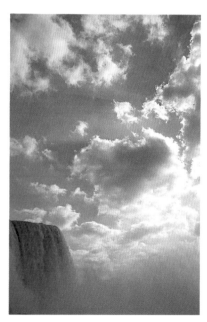

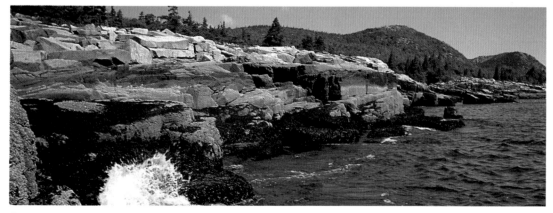

Spectacular places don't necessarily yield spectacular photographs. Although these may all qualify as good photos, they aren't great. It's not easy to make a great photo during a short visit to a place of spectacular scenery.

Dimensions

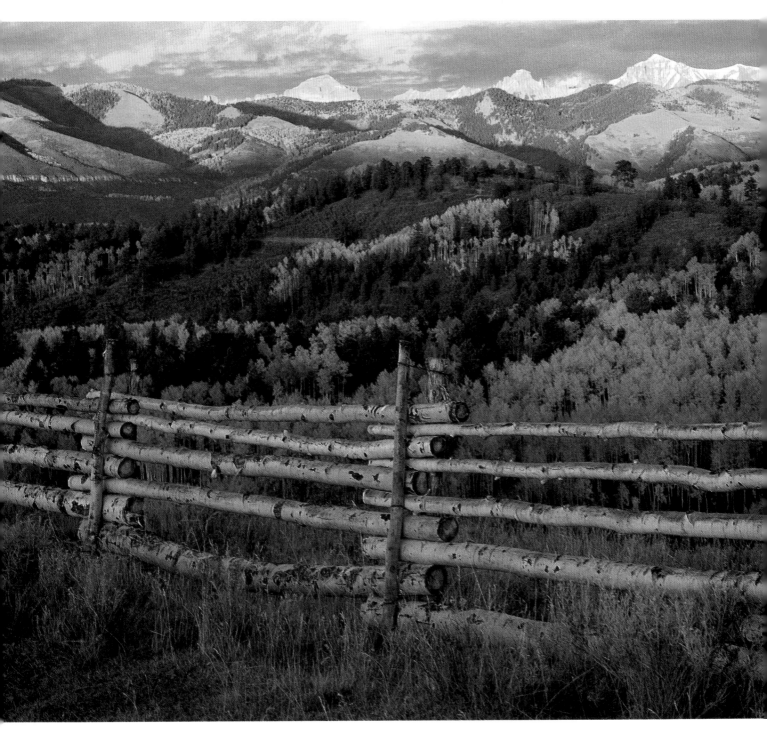

The front-to-back sharpness from the foreground fence through the hills to the background mountains conveys a strong sense of distance. The beauty of the photo derives from the viewpoint and composition as well as the incomparable autumn scenery described by the late afternoon lighting.

Height, breadth and depth—these are the dimensions of the physical world. But a photograph exists in only two of these—height and breadth. In a photograph, depth, form, distance, and space are all illusion. We can no more feel the forms of a photograph or stroll through its depth than we can bask in the warmth of its sunlight. And yet, a hundred times each day every one of us unquestioningly accepts the photographic illusion.

A magician creates illusion by distracting us with a flourish of motions and chatter, showing us one thing so that he can hide another. But as we shall see on the following pages, a photographer builds dimensional illusion by showing us what we need to see.

THE PERCEPTION OF DEPTH

The perception of depth is an integral and automatic part of our everyday visual experience. We rarely have to stop and think how far to extend our arm when reaching for the salt, or when to stop the car so we don't drive through the garage door. But in composing a photograph, we must consciously use our knowledge of human vision and photographic technique to establish a convincing re-creation of three-dimensionality.

The illusion of depth brings a heightened sense of reality to a photograph. When the feeling of space and distance is strong, we cease to see the photograph as a superficial object and accept it as a window upon the world. It entreats us to enter its fantasy, to walk among its spaces, to caress its forms, to travel to its distant horizons.

If you've looked at old-fashioned stereo pictures in a hand-held viewer, you know how potent the illusion of depth can be in a photograph. Stereo pictures create a perception of depth

so convincing, you're tempted to reach into the scene and pluck an apple from a tree.

Although the illusion of depth in ordinary photographic means is less profound, it is still possible to vividly reveal space and distance. It's important to remember, however, that vast distance is not a prerequisite to displaying depth in a photograph. A bed of tulips can appear just as three dimensional as a mountain range.

To better understand how depth works in a photograph, it's helpful to understand how the human mind perceives the three dimensions.

Using a system called binocular vision, the brain merges into one the separate images sent by the left and right eyes. The brain then sifts and compares the differences between the two signals and makes a judgment about the distances between various scene elements (it's this principle that is at work with stereo photography). The mind also sorts cues from the movements of the head and eyes as they scan a scene.

And by considering certain known facts—the approximate size of a tree or a cat, for example—the brain can build a fairly accurate interpretation of the three-dimensional world. The mind can be fooled, but usually only in new or unusual situations. Anyone who's taken a leap from a high-diving board knows how difficult it can be to accurately judge the distance to the water's surface.

In a photograph, visual cues create the sensation of depth. These cues trigger the perception of distance by indicating that objects exist in different levels of a scene. Some cues intensely affect the perceived depth, others act more subtly. But without them, depth disappears. On the following pages we'll take a look at a number of familiar depth cues that you can put to work in your photographs.

MONOCULAR DEPTH CUES

The depth or spatial cues producing three-dimensionality in a two-dimensional image are monocular (one-eyed) in nature—that is, they do not rely on the benefits of binocular (two-eyed) vision for their effectiveness.

Monocular cues borrow from our visual experiences to alert the brain that certain elements of a particular scene are farther away than others—and that space exists between them. For example, we know from experience that in a row of identical houses, the distant houses are not actually smaller than those nearby, but because they appear to be smaller, we perceive them as being more distant—whether we're looking at them in real life or in a photograph.

People with similar cultural and environmental backgrounds share similar visual experiences and readily recognize these cues. People from radically different cultures may not perceive the cues and thus not perceive the depth in a photograph. Once you've become familiar with the cues and their effects, you can exploit them (either singly or in combination) to heighten the illusion of depth in your images. Or, by choosing viewpoints that downplay existing cues, you can suppress depth.

Aerial Perspective

Aerial perspective refers to how the atmosphere alters the appearance of light. As distance increases, the atmosphere scatters more light, causing subjects to look increasingly pale, less sharp, and to have lower contrast. Distant subjects may look somewhat more blue or brown. The effect is most noticeable on landscapes over several miles but may also be apparent in hazy urban areas.

Although it's nearly half a mile to the closest buildings, the darkened foreground hides any distance cues, minimizing the sense of distance.

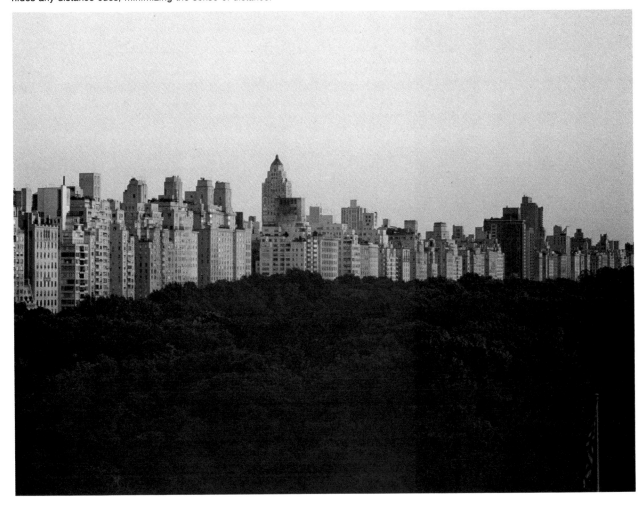

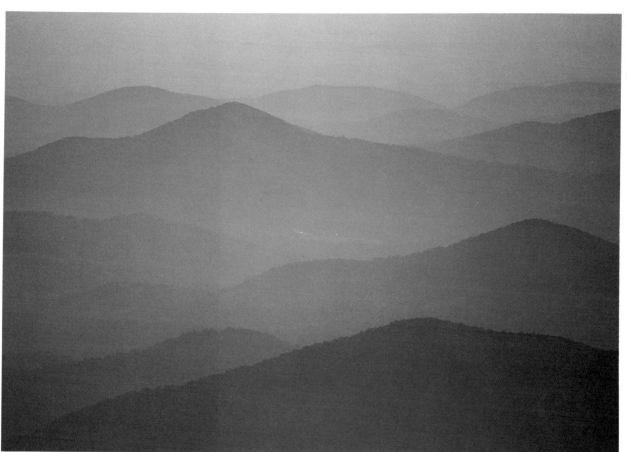

The buildup of haze over distance is a common visual cue revealing distance. It's most noticeable when obvious subjects are located at varying distances, such as with this chain of receding mountains.

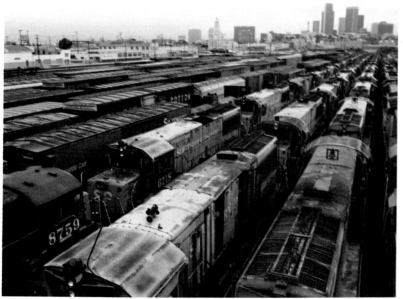

Linear Perspective

Perhaps the most powerful and most often used cue to gauge distance is linear perspective. Linear perspective is the apparent convergence of receding parallel lines and planes. Railroad tracks, roads, and skyscrapers show obvious linear perspective. A cobblestone plaza shows a less obvious form of linear perspective. You can exaggerate linear perspective by using a wide-angle lens and including foreground lines as well as background lines.

The trains converging at the city skyline exemplify linear perspective and exaggerate the depth of the scene.

Upward Dislocation

Upward dislocation means that distant subjects usually appear higher in the visual field. By showing a subject high within a photograph, you add an additional cue that further emphasizes the distance to the subject. You can exaggerate the effect by using a low viewpoint and including the foreground.

This example of upward dislocation to stress distance gets an assist from the rugged terrain in the foreground that makes the distance seem even further because it would be so difficult to traverse.

Size Diminuition

Size diminuition means that the more distant a subject is the smaller it appears. From experience, the mind knows that certain things, such as houses and cars, have certain sizes. When they appear small, the mind reasons that they are far away. In photographs, this cue can be used to stress distance by including a foreground subject of known size. The difference in image sizes between foreground and background subjects emphasizes the distance between them.

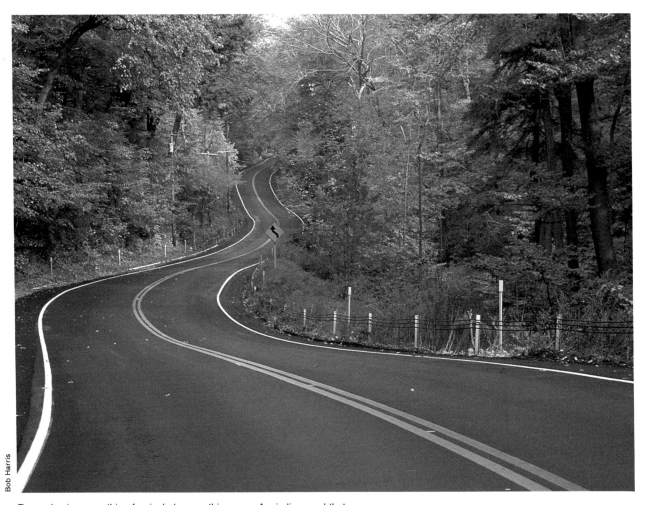

To emphasize something far, include something near. A winding road that seemingly starts at your feet and diminishes into the distance works here. 50 mm lens set at f/11.

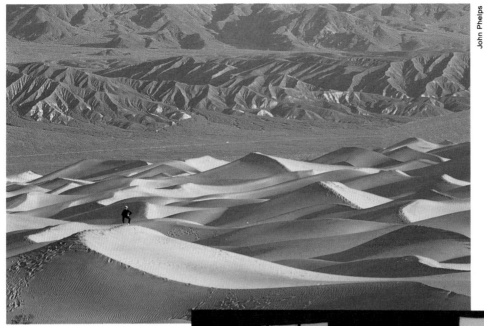

John Phelps

Hilary N. Nuffer

Above, shadowing reveals the volume (form) of things. Here, it also plays a part in clarifying distances by making us aware that the dunes and ridges are separate features with some distance between them.

Right, if one thing partially covers our view of another thing, we perceive it to be in front of the other object. This is overlap.

Shadowing

Shadowing can enhance the perceived depth of a scene in a number of ways. Shadows that fall across objects increase their three-dimensionality by revealing form and volume, and exaggerating surface texture. In stressing overall distance, shadows enhance remote forms and accent the spaces between them. The elongated shadows cast by strong backlight or sidelight exaggerate distance, particularly when viewed from an elevated position. Generally depth seems greater in scenes with contrasty lighting than in those with flat lighting.

Overlap

When one object overlaps another, it becomes obvious that one object is in front and one behind. A scene with a boulder partially obscuring a tree trunk must contain depth because the boulder is known to have volume and is in front of the trunk. As more objects overlap in a scene, the appearance of depth generally increases. Because overlap is a relatively weak cue by itself, you should combine it with other cues, such as aerial perspective, for greater effect.

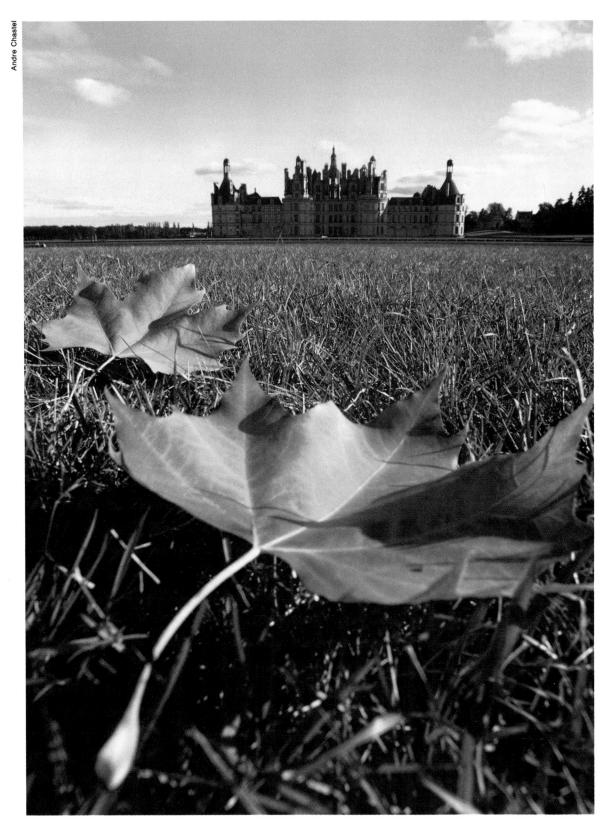

By stooping and virtually poking a wide-angle lens into the leaf, the photographer
was able to make the leaf seem large enough to hold the background castle in its
palm. The result is an arresting photograph that strongly reveals distance.

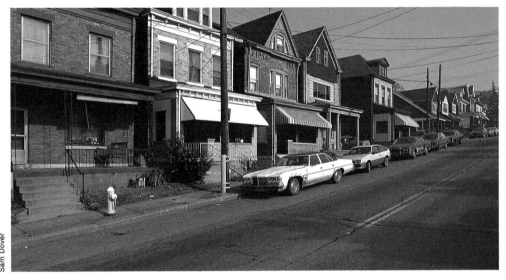

Sam Dover

When conveying depth, choose a side view that stresses linear perspective rather than a head-on view that seems two dimensional.

EMPHASIZING DEPTH

Viewpoint plays the most decisive role in revealing depth. Viewpoint seals not only the spatial and physical relationships within the frame but also the very depth cues to be contained. Since a photograph is seldom dedicated solely to depth, you must sift out the viewpoint that satisfies both your interpretation of the scene and your need (if any) for depth.

Exploit linear perspective and size diminuition, the strongest depth cues, and a sense of depth will follow. To stress linear perspective, photograph from a position that best shows lines

converging. For instance, if you photograph a row of houses head on, you minimize linear perspective. However, by standing at an angle to them so they run diagonally through the viewfinder, you display the convergence of lines. You emphasize depth.

Size diminuition works best when you include a subject in the immediate foreground, within arm's length if you would. This is the technique used for the well-known framing rule when you place distant mountains beneath or between the arch of foreground

branches. The near reveals the distance of the far. The near subject acts as a marker. It needn't form a frame. Whatever the location within the photo, any subject in the immediate foreground, be it stones at your feet or branches overhead, will stress the distance to subjects in the background.

Although linear perspective and size diminuition are two of the most powerful depth cues, when you want to strongly imply depth, use as many depth cues as possible.

43

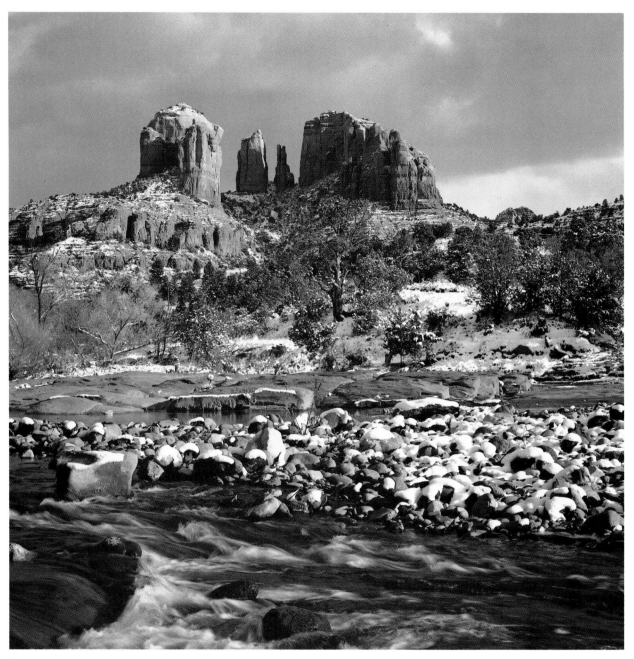

The front-to-back sharpness of this photograph mimicks the way the mind views a scene.

Lens focal length can affect depth cues. Technically, only viewpoint, not focal length, affects perspective. However, in practice, because a photographer often changes viewpoint as well as lens focal length, and because of the way photographs are viewed, perspective often appears to be changed by focal length. Through its ability to include nearby objects while greatly reducing the size of more distant ones, a wide-angle lens seems to exaggerate the effect of size diminution. For instance, you can make a daisy in the immediate foreground tower over a barn in the distance, creating the illusion of great space between the two.

Wide angles also amplify linear perspective by causing a more dramatic convergence of parallel lines. You readily see this effect when you point a wide-angle lens up at a tall building or aim it down at railroad tracks.

In most cases, a normal lens will provide a rendition of perspective closest to that seen by our eyes. Telephoto lenses appear to compress perspective and reduce depth.

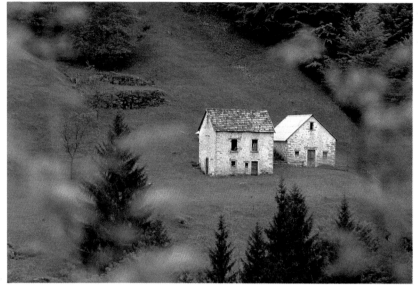

Sometimes, an out-of-focus foreground that contrasts with an in-focus background can also stress distance. The foreground has to be definitely out of focus and usually works best when you seem to be looking through it, such as with the branches in this photograph.

Soft, shadowless lighting, monochromatic colors, and indistinguishable shapes—all combine to minimize the sense of depth in this picture. The distance from front to back is great. And there are just enough cues for you to roughly determine that distance. But the distance is not obvious.

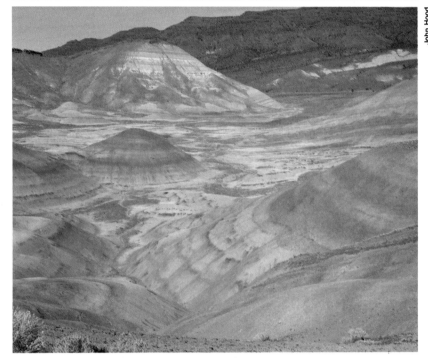

Because we perceive scenes as having overall sharpness, we will also perceive photographs with front-to-back sharpness as having greater depth than those with limited depth of field. To achieve great depth of field, use the smallest lens aperture and focus on the hyperfocal distance of the lens.

In some situations, you can intensify the feeling of depth by throwing a particular area out of focus. The most common example of this is when an out-of-focus foreground element is used to establish a frame for the main elements of the scene—a leafy tree limb framing a distant peak, for example. The contrast between sharp and unsharp suggests that considerable space exists between the two regions of the scene. To avoid ambiguity, make sure the out-of-focus portion of the scene is very out-of-focus, not almost in-focus.

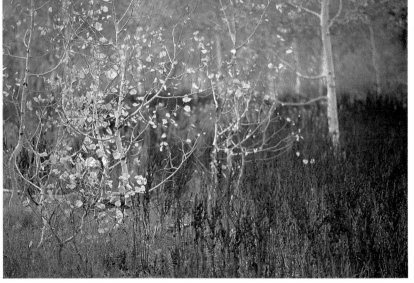

To suppress depth exclude as many depth cues as possible. A 200 mm telephoto lens was used here to compress the midground tree with dead leaves into the background trees. Although many yards apart, there are no obvious spaces between the trees because they appear to share the same plane.

SIZE AND SCALE

Anyone who's ever aimed a camera at Niagara Falls or the Grand Canyon can attest that capturing the vastness and grandeur of nature on film is no easy task. In a photo, sizes shrink and spaces diminish. Compared to the magnificence and awe imparted when viewed in person, the spectacular places and wild forces of nature seem toylike in a photograph. The Upper Fall of Yosemite Falls drops over 1400 feet. In a photograph, that 1400 feet becomes a few inches. Towering cliffs, wild rivers, sweeping desert dunes—all pale by comparison to our memories of them.

What's missing is a sense of scale. The true measure of a landscape is only indicated when objects of known size are included for contrast or comparison. In person, you have the pebbles at your feet, the trees in the distance, and the sea gull overhead to indicate scale. But when you isolate the subject in the viewfinder, you also exclude many cues to size and scale. To give a convincing interpretation of scale, you must compose your scene to include one or more elements of known size.

When Uncle Herb stuck a stiff, self-conscious Aunt Martha in front of a giant redwood, he may not have done much for the esthetic quality of the family vacation pictures, but he did provide a means for measuring the true dimensions of the scene. Everybody knew how tall and wide Aunt Martha was, and she provided a perfect sense of proportion for judging the hugeness of the tree.

The human figure has long been recognized as a yardstick for measuring human creations. In 1858, when Francis Frith packed up and hauled his 16 x 20-inch glass plates and bottles of chemicals from England to Egypt, he made sure his countrymen would know the gargantuan nature of the pyramids by including people in his photographs. People provide not only a measure for scale, they also add human interest to the picture.

But people posed in pictures are not always appropriate. Their presence can tame a wilderness or tarnish its beauty. Fortunately most scenes offer alternatives. Often you can include natural elements to indicate size without disrupting the mood of the image: a dead tree at the bottom of a waterfall, a cactus blooming at the edge of a dune, a mountain goat poised atop a crag. Generally the greater the size differential between large and small, the more effective the use of scale becomes. That is, as long as your indicator of scale remains plainly visible. When it's too small to notice, it no longer serves as a marker for scale.

In some situations, it may be impossible (or undesirable artistically) to include such an element in a scene. But you can still use camera technique to indicate scale. The amount of space you give individual objects conveys a strong impression of size. A rock formation occupying the entire frame is perceived as much larger than one occupying only a corner. Format, too, affects perceived size of key elements. Horizontal framing emphasizes the expansiveness of wide open spaces, while vertical framing emphasizes the height of tall scenes—waterfalls, skyscrapers, or mountain peaks.

Manmade landscapes present less of a problem in relating size and scope because we are familiar with their sizes. Even in the most isolated compositions, there is usually some element—a doorway, a trellis, a bicycle—that gives away the true dimensions of a scene.

There may be times when you may want to disguise the scale of a scene, to concentrate attention on a design or pattern, or to create a false sense of scale. By omitting indicators of size, you can create a fantasy environment where the viewer is left to create his own interpretation of scale: The tiny ripples of a sandbar look like vast desert dunes; the snow drift blocking the driveway seems so enormous you half expect to see hikers coming over the crest.

Although it's hard to miss the immensity of Upper Yosemite Fall, in this photo its enormity is keyed by the lone pine at the bottom of the drop. The pine tree becomes a focal point because it not only contrasts tonally with the waterfall but because its stability also contrasts with the cascade of water. Gordon Brown

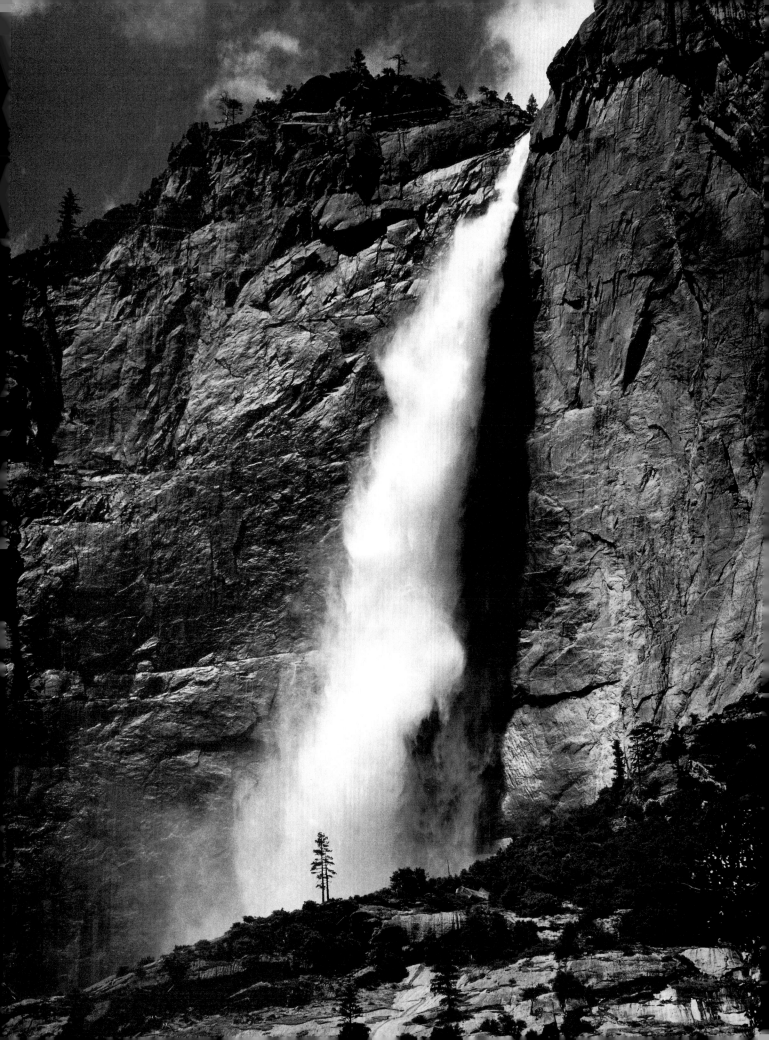

f/3.5

DEPTH OF FIELD

Depth of field is the distance between the nearest and farthest points in a scene that appears sharp to the eye when the camera's focus is set. Limited to only a few millimeters in an extreme close-up photo, depth of field can extend for miles in a distant landscape. Except for close-up subjects, roughly one third of the depth of field is in front of the subject and two thirds behind it.

Three important factors dictate the amount of depth of field in a landscape photograph: lens aperture, lens focal length, and subject distance. Change any one of these and the depth of field, as well as the emphasis of the photograph, changes.

Understanding how these factors can affect a scene enables you to manipulate depth of field as needed. The most critical factor is aperture. The smaller the aperture, the greater the depth of field.

Because depth of field tends to increase faster behind the point of sharp focus as you decrease aperture, it's often necessary to refocus on a point closer to the camera to even out the depth of field. (See hyperfocal distance page 50.)

Changing to a shorter-focal length lens or backing away from your subject reduces the image size, thus increases the depth of field. Changing to a longer-focal length lens or moving closer to the subject increases image size, thus decreases depth of field. Increase image size, lose depth. Decrease image size, gain depth.

f/8

With an SLR camera, you can make a visual check of the actual depth of field by using the depth-of-field preview button (not available on some cameras), which closes the lens opening down to the shooting aperture. Because the viewfinder image is small and dark when a small aperture is used, you may prefer to use the depth-of-field scale marked on your lens. Using it, you can determine the actual depth of field in feet or meters for each f-stop.

Taken with a 135 mm lens, these three photos show that depth of field increases as the aperture size grows smaller.

f/22

24 mm lens, f/4

135 mm lens *f*/4

For lenses of different focal lengths set to the same f-stop, depth of field is the same when the image size of the subject is kept constant (by varying camera-to-subject distance).

50 mm lens, f/4

50 mm lens, f/4

Increasing image size decreases depth of field. Decreasing image size increases depth of field. You can alter image size by varying the camera-to-subject distance or by changing the focal length of the lens.

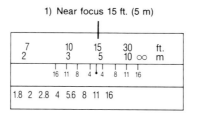
1) Near focus 15 ft. (5 m)

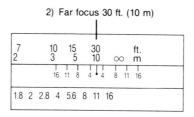
2) Far focus 30 ft. (10 m)

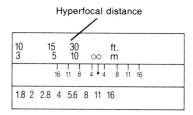
Hyperfocal distance

Depth of field extends
from 10 ft. (3 m) to 30 ft. (10 m)

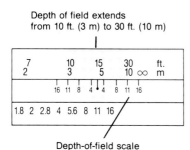
Depth-of-field scale

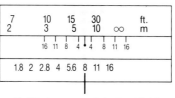
3) f/8 gives correct depth of field

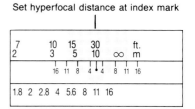
Set hyperfocal distance at index mark

USING THE DEPTH-OF-FIELD SCALE

Learning how to use the depth-of-field scale on your lens can save you a lot of time in planning a photograph and will help you choose the correct aperture for any situation—whether you seek to maximize or minimize depth of field.

The depth-of-field scale is between the aperture ring and the distance scale on your lens. It consist of pairs of numbers that correspond to the f-stops. One half of each pair is on either side of the focusing index mark (sometimes rather than numbers it uses color-coded lines that correspond to certain apertures).

To use the scale, simply focus on your main subject and then read the distances that fall opposite each of the marks that correspond to the aperture you're using. In this illustration, the lens is focused at 15 feet and the aperture is set at f/11. Find the two f/11 marks on the depth-of-field scale and read the distances opposite them. Here the depth of field would extend from approximately 10 to 30 feet (3 to 10 metres). Notice that the depth of field is greater behind the main focus which is at 15 feet (5 metres).

USING THE SCALE TO DETERMINE APERTURE

You can also use the scale in reverse to find the aperture giving the minimum depth of field required for a particular situation.

1) First, focus on the nearest element you want to be in sharp focus and note that distance. In this case the near focus is 15 feet (5 metres).

2) Now focus on the farthest point of interest and note that distance. Here the far focus is 30 feet (10 metres).

3) To find an aperture that will cover this range, simply rotate the focusing collar until these two distances match up with a pair of aperture marks. Set your lens at this aperture and you will have sufficient depth of field to keep the entire scene sharp. In this instance you would set the aperture at f/8.

If you experiment with the scale, you'll soon notice that as you move closer to the subject, a much smaller aperture is necessary to maintain a given depth of field.

HYPERFOCAL DISTANCE

Once you've learned how to use the depth-of-field scale, you can use it to figure the hyperfocal distance for any particular aperture. Hyperfocal distance is the nearest place in the scene that will be sharp when the lens is set at infinity. By setting the lens to the hyperfocal distance, you obtain the maximum depth of field for a given aperture.

For example, with a 50 mm lens focused on infinity and set at f/11, the hyperfocal distance (nearest point in sharp focus) is slightly less than 30 feet (10 metres), as indicated by the depth-of-field scale. If you refocus the lens so that the 30-foot (10-metre) mark matches up to the focusing index mark, everything from half that distance (15 feet) to infinity will be in acceptable focus. The smaller the aperture, the closer the hyperfocal distance comes to the lens.

Basically this technique lets you shift the range of depth of field closer to the lens, rather than wasting it "beyond" infinity—enabling you to get maximum depth of field and still keep infinity sharply focused. Looked at another way, you obtain maximum depth of field for a given aperture by aligning the infinity mark to the appropriate aperture mark on the depth-of-field scale.

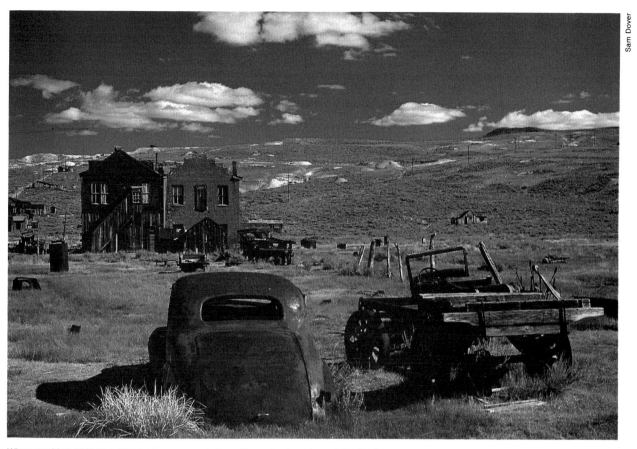

When working without a tripod or on overcast days, it's easier to get great depth of field by using a medium- or high-speed film. KODACHROME 200 Film and a 50 mm lens set at f/16 were used here.

As these three photos show, the area of focus and the amount of depth of field can drastically alter the appearance of a photograph. The shallow depth of field in the first two photos stresses first the branch and then the forest floor. In the final photo, great depth of field shows both with equal emphasis.

51

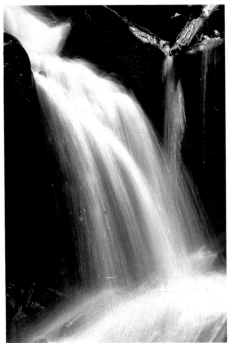

1/8 second

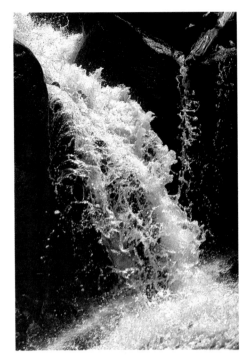

Herb Jones

1/500 second

Waterfalls generally look best when you blur the water by using a slow shutter speed.

SHUTTER SPEED

Because the bend of roads and the rise of mountains can move only grammatically, the usual concern of landscape photographers for shutter speed is only that they set it correctly for exposure. However, two situations do concern shutter speed. The first is when moving elements do indeed inhabit the landscape. The second is when shutter speeds are so long that exposure needs to be increased because of reciprocity effect.

Natural moving elements are few but common. Water in the form of waves, ripples, streams, waterfalls, rain, and snow is one. Wind and things blown by it is the other. Manmade movement across the landscape is even more common: trains, cars, people, planes all move.

Confronted with a moving element, you must decide whether to freeze it with a fast shutter speed or to blur it with a slow shutter speed. Freezing is absolute and cannot be done in degrees. Blur is relative, increasing with

each slower shutter speed until the moving subject may vanish with extremely long exposures. Blur conveys a sense of motion.

How much blur? What shutter speed to create it? The first is a matter of taste, the second a matter of trial and error, although starting points can be suggested. A pleasant blurring of naturally moving subjects like windblown trees or waterfalls usually requires a shutter speed of $1/15$ second or longer. To increase your chances of creating pleasing blur, take several exposures, varying the shutter speed by a factor of 4 ($1/4$ sec, 1 sec, 4 sec). For falling rain and snow, shutter speeds of $1/15$ to $1/60$ second usually render them as streaks. Blurring snow is variable because its rate of descent varies with the wind. The contrast of a dark background will better reveal the streaks. Because of the high speed of many manmade subjects, use your judgment both for stopping them or blurring them. Blurred subjects usually

look best when there is something sharp in the scene. The contrast between sharp and blurred heightens the sense of motion.

The use of small apertures to gain great depth of field often requires slow shutter speeds to provide sufficient light for the film. Most black-and-white and color films become less sensitive to light at exposures 1 second or longer and require more exposure than indicated by the meter. Long exposures also often affect the contrast of black-and-white films and the color balance of color films. Unless color accuracy is critical, the shift is usually not enough to be concerned about. Changes resulting from long exposures are referred to as reciprocity effect.

Of greatest concern is obtaining the correct exposure. To obtain correct exposure, adjust it according to the table on the next page.

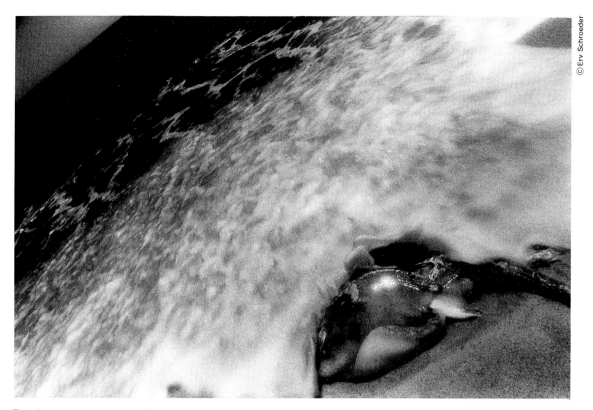

By using a shutter speed of 1/30 second, the photographer was able to animate the ocean in this still photograph. The photographer purposely used a low viewpoint and tilted the camera (notice horizon in upper left corner) to reinforce the notion of the sea as all-powerful as it reclaims this dead skate.

Exposure and Filter Corrections for Reciprocity Effect

Film	Exposure Time (seconds)	
	1 sec	**10 sec**
KODACOLOR VR-G 100 KODACOLOR VR-G 200	+ 1 stop CC20Y	NR
KODACOLOR VR-G 400	+ ½ stop, no filter	+ 1 stop, no filter
KODACOLOR VR 1000	+ 1 stop, CC10G	+ 2 stops, CC20G
KODACHROME 25	+ ½ stop, no filter	NR
KODACHROME 64	+ 1 stop, CC10R	NR
KODACHROME 200	NR	NR
EKTACHROME 100	NR	NR
EKTACHROME 200	+ ½ stop, no filter	NR
EKTACHROME 400	+ ½ stop, no filter	+ 1½ stops, CC10C
PANATOMIC-X PLUS-X, TRI-X	+ 1 stop*	+ 2 stops**
TECHNICAL Pan	no correction needed	+ ½ stop
T-MAX 100 T-MAX 400	+ ⅓ stop	+ ½ stop

NR—Not recommended for critical use as colors shift, although will often be suitable for landscape photography depending on your tastes. Increase exposure ½ to 1 stop and bracket.
*Reduce development of film by 10%.
**Reduce development of film by 20%.

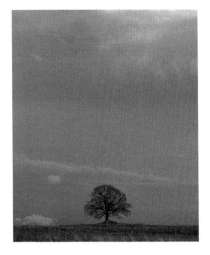

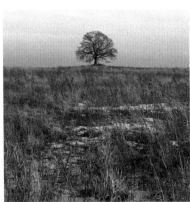

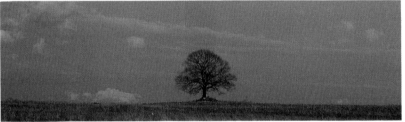

Derek Doeffinger

With a high horizon, land filling the frame diminishes the sense of space and freedom. A low horizon and an empty sky, restore the sense of spaciousness.

EXPLOITING SPACE

In many landscape compositions, space strengthens the illusion of distance and three dimensionality. The spaces that separate and surround various physical elements help to define forms, establish placement of elements within the frame, and lead the eye through the scene. When space occupies enough of the frame, however, it transcends its role as a compositional device and becomes a primary creative component in the photograph.

Excessive space imparts a feeling of openness and freedom that exaggerates the scope of a photograph and

offers the viewer a heightened feeling of presence in the scene. And by simplifying a composition, large spaces rivet our attention on a specific subject.

Spaces work best when they surround a single main element of known size—a solitary hilltop oak, a wading shore bird. Because of its relative smallness in the frame, however, the placement of that element becomes crucial. Like a bowl of fruit on a table, the center of the frame works well to hold a subject shown small in a vast space. With the subject positioned anywhere else, the rest of the

photo may appear empty. Even so, in some instances, a subject placed to the extreme left, right, top, or bottom, enhances the feeling of space or creates a desired imbalance.

What comprises the open space can influence our perception of the photograph. The most common source of open space is sky. Although skyscrapers, trees, and planes may intrude upon the sky, we do not find empty sky unusual, because, whether we are in city or country, we can often find some viewpoint that shows only sky. An empty sky generally imparts little more than a feeling of serenity or blandness.

Vast stretches of empty land on the other hand can be more complex. A desert can be bleak, barren, desolate. An empty beach can be peaceful. Rolling plains can be inspiring. Empty land almost always implies a feeling of silence, of just the wind rustling through the brush.

To exaggerate the vastness of the sky, place the horizon low in the frame and use a wide-angle lens (28 mm or wider). With a low horizon, the sky soars, dwarfing the subject and dominating the composition. When the sky dominates, for balance, consider placing a contrasting visual weight in the lower portion of the frame. Visually heavy, small dark-toned objects can counterbalance a large area of sky.

Fog, snow, water, sand—each can be readily exploited to enhance the impression of a scene's vastness or to heighten the isolation of a particular subject: the mirror-calm waters that surround a drifting sailboat, the pristine meadow of snow that engulfs a lone cross-country skier, or the towering wall of storm clouds shrouding a hilltop farm. If space is not instantly apparent in a scene (and often it's not), search for it through changes in viewpoint or camera angle.

Whatever the source of the space, take care in exposing since the brightness of this large area will likely determine the exposure unless you override the meter. If the detail in the main subject is important, try to meter it separately. If getting close is impossible, expose using a meter reading from a nearby subject of similar brightness.

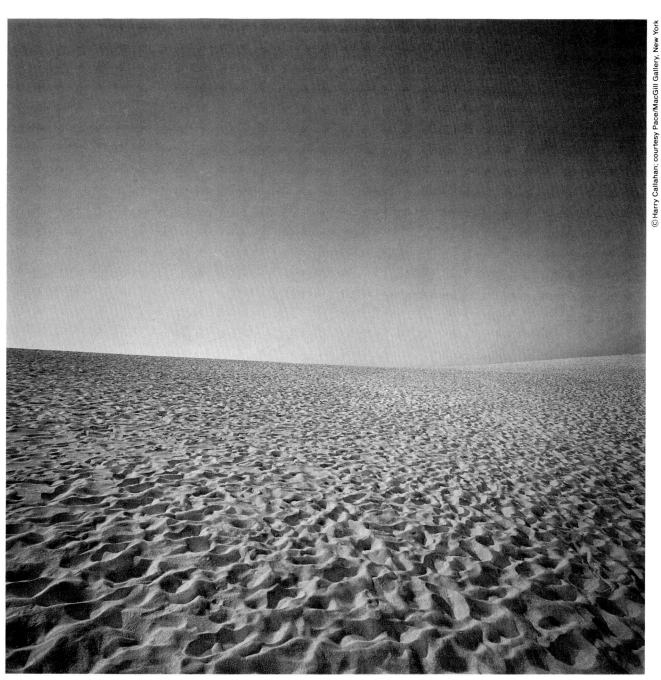

Mute evidence to the throngs earlier lolling on towels with radios blasting,
thousands of footprints seem to mock the silence of this "empty" beach.

Design

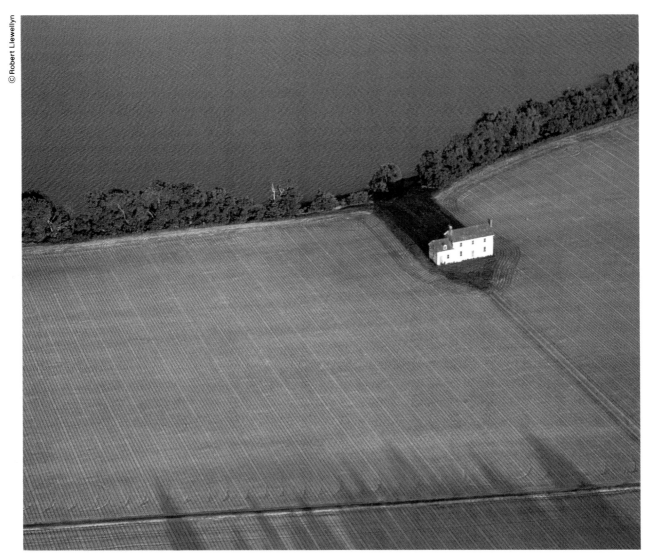

© Robert Llewellyn

The corrugated field and wrinkled water are but textures in a tapestry of colored shapes: brown (soil), green (trees), and blue (water) with the one bright spot of the house being the highlight.

Design is the placement of scene elements in the frame. Every technical and artistic decision you make, from the moment you choose a subject to the instant you press the shutter, will be reflected in this arrangement.

The aim of a good design is simple: To communicate to the viewer your interpretations of a particular scene—its drama, its beauty, its tranquility. Photographer Ernst Haas described it this way: "The juxtaposition of objects in a picture should create an image that conveys your feelings as well as your thinking about the scene."

Because each photographer feels and thinks differently, each will design photographs differently. Many photographers seek simplicity in their designs by creating minimal, almost abstract arrangements of elements.

To materialize your visions, recognize the various visual elements; understand the concepts of balance and imbalance, and subordination. For most photographers, design remains a process of intuition and experience. We've all heard certain photographers described as having "a good eye." And indeed, for many photographers the act of design seems instinctual.

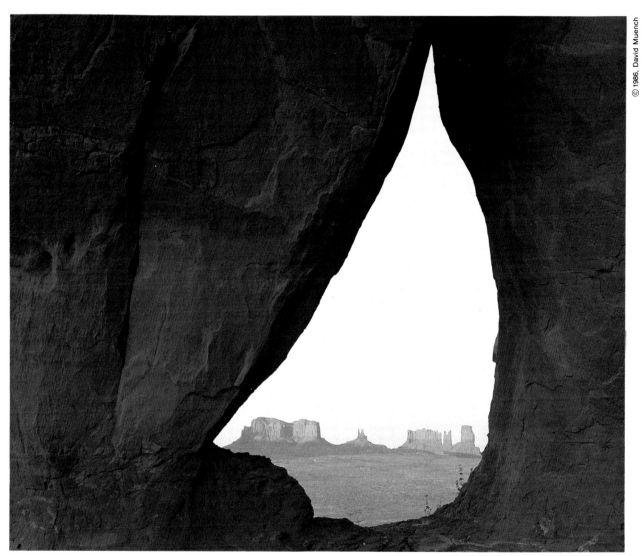

The formal composition of framing the rock formations inside the teardrop opening relates a stately and majestic interpretation. This photograph was taken in Monument Valley on 4 x 5-inch KODAK EKTACHROME 64 Professional Film.

They have a seemingly inborn flair for creating just the right visual balance or rhythm or finding the most arresting graphic and geometric combinations to make a scene come alive. Is their flair really a gift? Usually not.

Usually their ability derives not from a genetic endowment but from experience. Photographers who consistently create interesting designs have taken thousands of pictures and have faced enough design problems to know what works and what doesn't. That's what design is: a visual problem waiting to be solved. It's a problem that differs with each situation, and one that each of us must solve individually. Of design Paul Strand wrote,

If you have something to say about life, you must also find a way of saying it clearly. And if you achieve that clarity of both perception and the ability to record it, you will have created your own composition, your own kind of design, personal to you, related to other people's yet your own. The point I want to make is that there is no such thing as THE way; there is only for each individual, his or her way, which in the last analysis, each one must find for himself in photography and in living.

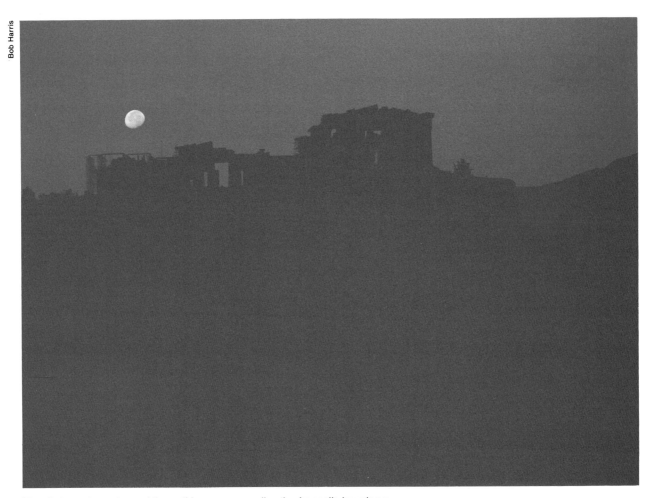

Bob Harris

The photographer enhanced the mythic aura surrounding the Acropolis by using a blue 80A filter and shooting in the early morning to catch the setting moon.

ELEMENTS OF DESIGN

What are the elements of design? Barns and fields, canyons and rivers, skylines and avenues? Perhaps. But more basic than these are the graphic elements: lines, shapes, forms, and textures. These are the components of all scenes, the building blocks upon which you must erect your visual superstructure.

An unnatural process, learning to see the various visual elements within the objects themselves isn't always easy. Ordinarily your eyes subconsciously flit across a scene, noting predominant features and ignoring secondary aspects. They see the barn but ignore the sidelight splintering its surface. They acknowledge the presence of a cow but overlook its graphic shape against the green hill. Ordinarily your eyes don't look, don't observe. Ordinarily, the lines, forms, shapes, and textures in a scene are inconsequential—excess visual baggage.

But in planning a photograph, you cannot expect to succeed if you see ordinarily. Instead, weigh and scrutinize each of the elements that make up an object. Probe beyond the mere presence of a tree to observe its shape, the swollen form of its trunk, the ragged texture of its bark, the curves of its roots. You may choose to enhance, suppress, or even exclude any of these traits, but first you must acknowledge them.

Most landscapes contain a complex assortment of design elements from a multitude of sources: the hulking form of boulders in the foreground, the delicate shapes of a pine grove in the distance and the snaking line of the stream that joins them together. Appraise each to decide its importance to the scene. The connections that you make, the visual relationships that you establish, are the seeds of interpretation, the beginning of finding *your* design.

The design of the stairs is manmade. But the design of the image is made by the photographer, who purposefully chose a viewpoint that isolated the stairs so that they seem to be descending from the skies. The interplay of light and shadows on the railing and treaders against a background of clouds makes for a light, airy image.

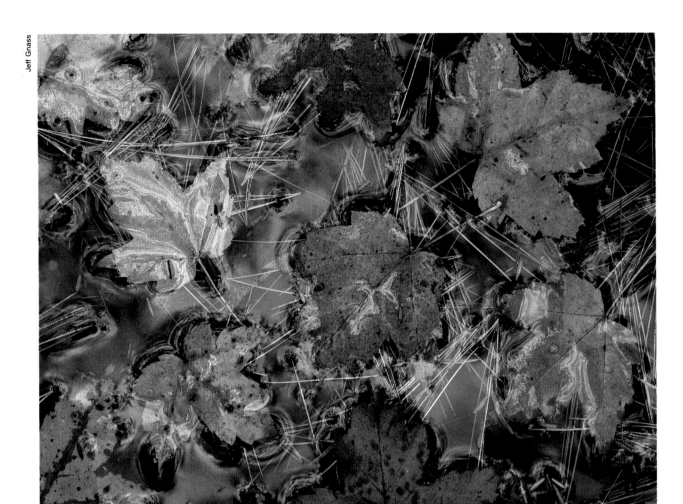

The repetition of the shapes of leaves and the lines of pine needles interrupted by watery reflections makes for a subtle but pleasing pattern. Shot with a 4 x 5 view camera on KODAK EKTACHROME 64 Professional Film.

PATTERN

Some of the most engaging and entertaining landscapes are those that include a strong pattern. Repetition of lines, repetition of shapes, repetition of forms, repetition of colors, these the eye cannot resist. Our attraction to pattern is evident in the fabrics we wear, the wallpapers we choose, and even the paper towels we buy.

In a landscape design, use pattern to impart a sense of order and harmony within a larger scene—or make it become the central focus of the composition. The freshly turned furrows of a cornfield bring a feeling of unity and rhythm to a picturesque farm scene, or, isolated, they create an abstract design.

In both content and design, the sheer variety of patterns that surrounds us is astonishing. From the spirals of a spider web to highway cloverleafs, the world abounds with patterns. Some, like the rows of windows in a skyscraper, are more or less permanent; others, like shadows gliding over a summer sidewalk or ripples spreading across a pond, are more ephemeral.

The keys to finding new patterns are viewpoint and awareness. By heightening your sensitivity to patterns you can find them in scenes that previously seemed to lack them. By looking at familiar subjects from unfamiliar vantage points, patterns that were all but invisible seem to emerge magically. For example, a colorful pattern of beach towels and umbrellas, so obvious from a high dunetop position, vanishes at beach level.

Crucial to the success of a pattern is its composition. Where pattern itself is the subject, frame it tightly. By cropping out distractions and extending the pattern to the edges of the frame, the pattern seems to run on infinitely. When pattern is but one element of a broader composition—rows of colorful sailboats in the foreground of a harbor scene, for example—choose a viewpoint that clearly reveals the design of the pattern without allowing it to monopolize the composition.

Oddly enough, the greatest danger of working with pattern is including too much repetition. Too strong a pattern bores rather than entertains. Interrupt it. Break its monotony by introducing a new element—a single row of yellow tulips in a bed of red ones. Offer just enough diversion to surprise the eye without destroying the pattern.

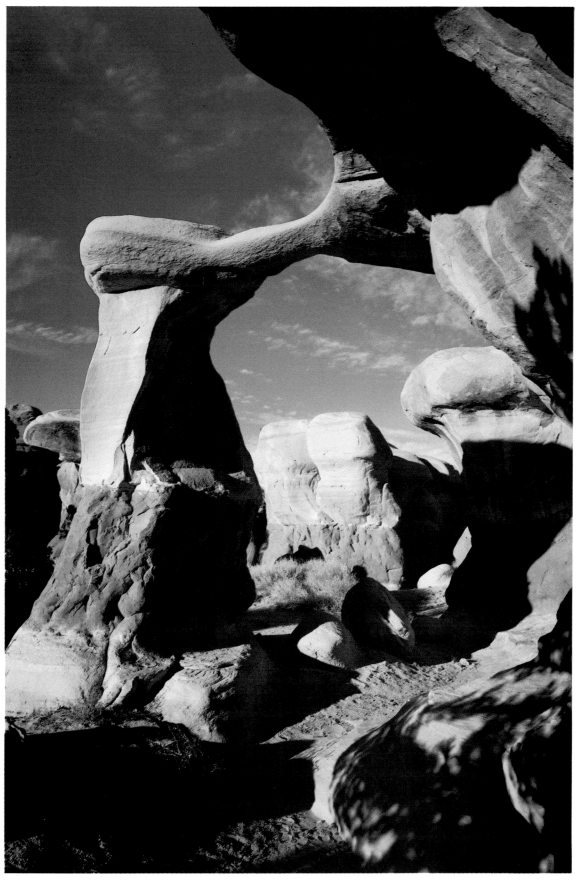

The pattern here is of light and shadow, forms and texture. A pattern need not be as obvious as a plaid shirt to succeed. Photo taken in the Devil's Garden, Escalante Canyon, Utah.

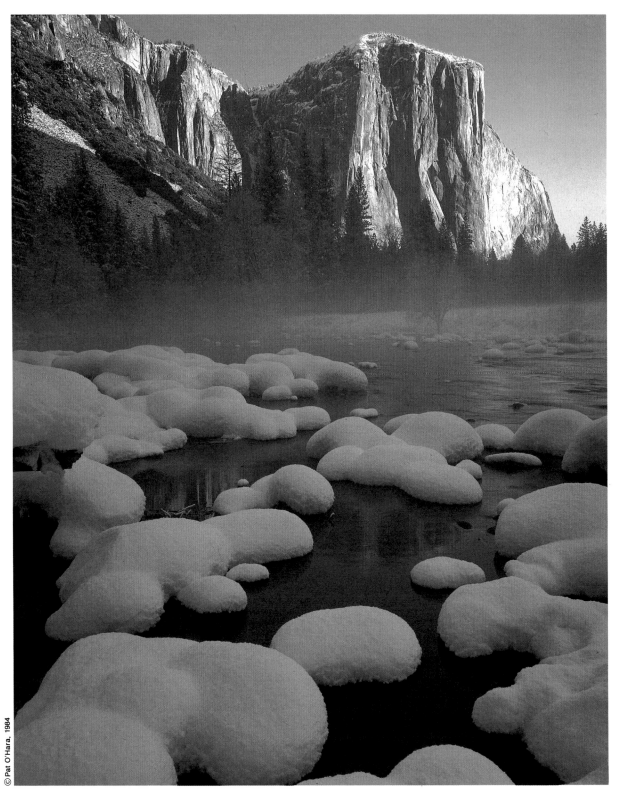

This is a nicely balanced picture filled with contrasts. The snow-covered hummocks in the foreground are in the shade, they are soft, and they are rounded. The rock face in the background is El Capitan in Yosemite National Park. It is sunlit, hard, and sharp-edged. Photo made on 4 x 5-inch KODAK EKTACHROME 64 Professional Film.

BALANCE AND IMBALANCE

Like a pleasing refrain in a musical composition, balance in a photograph soothes and calms the spirit. Just as the ear enjoys a harmonious melody, so the eye delights in visual balance.

You can create a nearly perfect design balance by using symmetry—an exactly equal distribution of space and subject within the frame. The problem with symmetrical designs, however, is that they are as static as a July heat wave, lacking any semblance of motion or anticipation.

Still, some subjects seem to lend themselves naturally to a symmetrical arrangement, particularly subjects that have an inherent symmetry. Reflections, for example, can create a striking mirror effect when you place the line of division (the edge of a pond, for instance) straight through the center of the frame. But as with patterns, often a slight visual distraction from the symmetry—a swan swimming through the reflection—improves the scene measurably.

A more flexible and dynamic method of creating balance is through the arrangement of objects by their visual weights. Visual weight is the perceived "lightness" or "heaviness" that subjects possess based on qualities such as tonal brightness, color, mass, or placement within the frame. Perceptual weight is somewhat subjective. But generally bright tones, light colors, and open spaces are considered light. Dark objects, solid masses, and muted colors are heavy.

Balancing a design therefore is a matter of contrasting opposing weights—dark against light, colorful against mute, or solid mass against open space—in such proportions that neither tips the scales too far in either direction. A silhouette of a city skyline at dusk, for example, would be offset nicely by a large expanse of sky. Because the sky is lighter than the buildings, it needs to fill more of the frame to maintain equilibrium.

While balance is a quality worth striving for in most compositions, no ironclad law demands you use it. You could choose to destroy the balance of a design. Imbalance can be a powerful tool in establishing a mood of suspense or anxiety. A massive rock formation at one edge of the frame without a contrasting counterweight at the other, for example, would create a distinct feeling of tension and insecurity.

Imbalance also makes the mind intensely curious. It will probe an unbalanced composition unmercifully to seek out the cause of the imbalance. It may never be satisfied with what it finds there, but for the photographer it's a good method for drawing attention to an otherwise mundane subject. It can also make a point. An imbalanced composition of a city could represent the imbalance of man with nature.

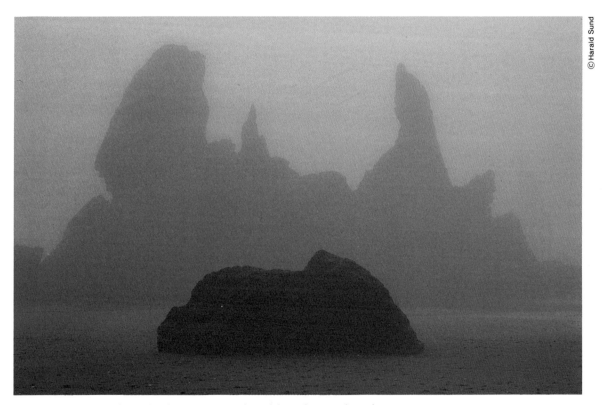

Photographs by Harald Sund often invoke a sense of mysticism, of awe and wonder for the land. Here the metaphor could be religious. The dark foreground rock stands like an altar. The background rock hovers over it like a robed priest with arms raised to conjure unseen powers.

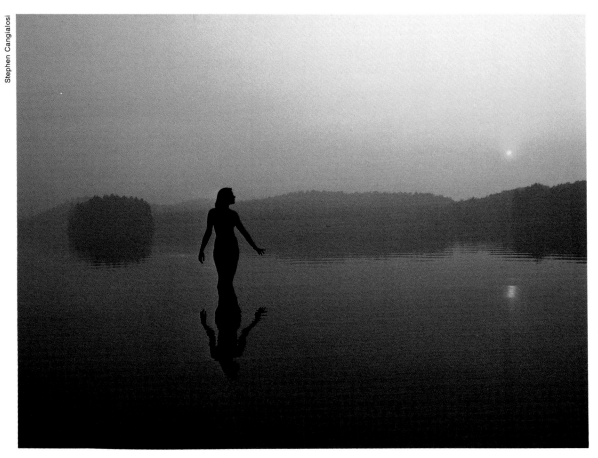

To break up the symmetry of this scene, the photographer placed a human figure along the left third. The silhouette of the figure stands out from otherwise nearly uniform tones. Its grace adds a touch of elegance.

EMPHASIS

Be selective. A photograph that attempts to say too much usually says nothing. As a rule, landscapes are more intense and interesting when there is one point of emphasis—an old shack, a bridge, bands of colors—that lures and captures the viewer's attention.

In other types of photography, portraiture for instance, creating emphasis is easier because the subject is more obvious. But in a landscape, the main element is often less apparent. Your task is to accentuate your chosen center of interest while maintaining the ambience of its surroundings.

Among the classic techniques used for steering the eye to a particular destination are lead-in lines. The eye has an intrinsic curiosity about lines and will investigate them eagerly. To draw the viewer to the main subject, place it along the route or at the convergence of naturally occurring lines.

Leading lines work best when they run from near to far in the frame and when there is a contextual relationship between line and subject—a fence leading to a barn or the crest of a wave leading to a windsurfer. Once you become aware of the potential of leading lines, you'll find them everywhere—in a long row of parking meters, a meandering dirt road, or in a freshly cut swath of lawn.

Contrasts in tonality or color can be another important source of emphasis. The first tree in a hillside of maples to slip into its autumn costume stands out like a house on fire—and is just as exciting visually.

Another significant factor in establishing emphasis is the position that a subject occupies in the frame. The familiar tendency (and it would seem the logical solution) is to drive a nail straight through the main subject and hang it squarely in the center of the viewfinder. For some subjects and intentions, centers are stagnant. For

others they are stable and tranquil.

One tried-and-true method for finding a dynamic subject placement is the rule of thirds—a technique long exploited by freehand artists. By mentally dividing the frame into thirds, both horizontally and vertically you create four key intersections. Any element placed on or near one of these intersections takes on a heightened degree of emphasis and importance. Subordinate elements placed at diagonally opposite intersections help create a feeling of unity and balance.

In the end, however, realize that you cannot bend a scene to a rule. Each scene is different. Each has its own feel. Looking through the viewfinder, play with the composition until you find the one that works for this scene, the one that feels right for this scene.

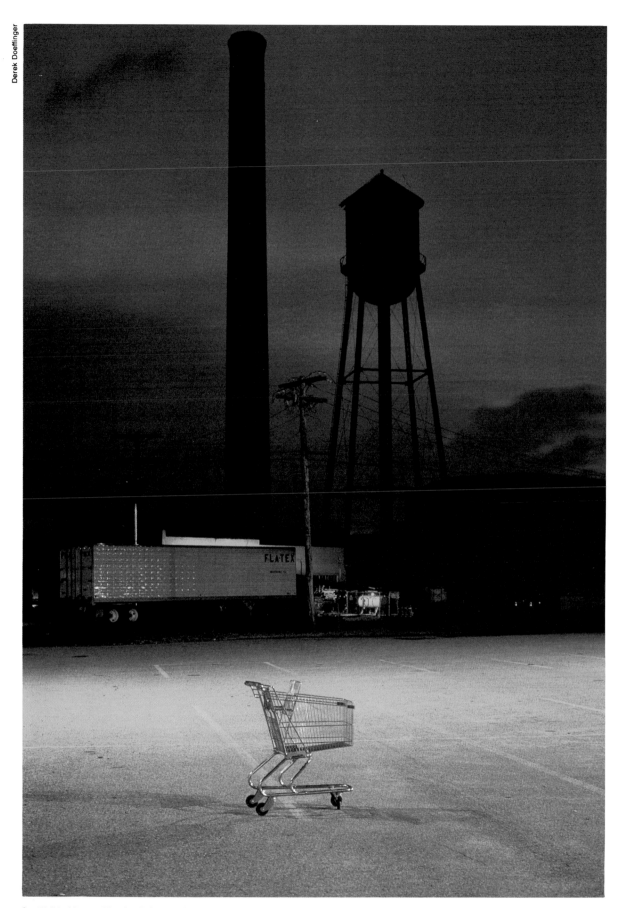

Derek Doeffinger

Spotlighted by parking lot lights, a shopping cart stands out against a smokestack and water tower looming in the dark. Shot with a 24 mm lens, the exposure was 30 seconds at f/4 on KODACHROME 64 Professional Film. A faster film such as KODACOLOR VR-G 400 Film would be better suited for such low light levels.

Light on Land

More than ambergris, a Gutenberg Bible, the philosopher's stone, the Holy Grail or a seat at the Super Bowl, a landscape photographer treasures light. Not just any light but a certain light. And more than a certain light, it has to be the decisive light. For the decisive light, many a landscape photographer would sell his soul (which may be the only non-photographic possession of a dedicated landscape photographer).

Just as light itself has skirted precise scientific definition, so does "decisive" light defy description and ever elude the photographer. Why? Because it can't be defined or found by itself. The decisive light derives not from a particular type of lighting but from the subject and the photographer.

What Ansel Adams at the base of Half Dome may have proclaimed as light supreme, another photographer in the streets of Sioux City may dismiss as brash. The decisive light may be dramatic: planks of light shooting through a thunderhead over the Grand Tetons. It may be passive: the diffuse light of an overcast day caressing fields of sunflowers. In the end, the decisive light is that which matches the photographer's intentions and style.

Whatever form it takes, the decisive light is a catalyst. Until it's stirred in, the formula of you and the scene remains inert. Tip in some decisive light, and the scene begins to bubble.

However, if you are unaware of the qualities of light and their effects, the reaction may be bubbling before unseeing eyes. Becoming sensitive to the qualities of light is one of the more sophisticated aspects of photography. The three traits of light that play across the land are direction, color, and quality.

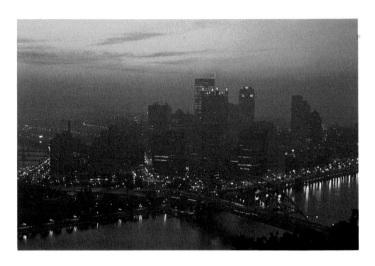

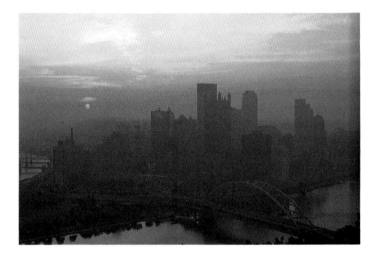

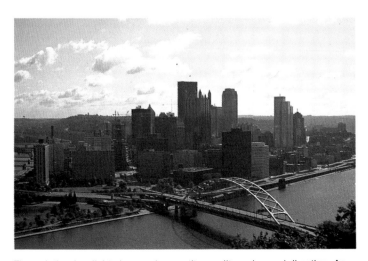

Through the day, light changes in quantity, quality, color, and direction. As shown in this dawn-to-dusk study of Pittsburgh, all these qualities affect appearance and mood.

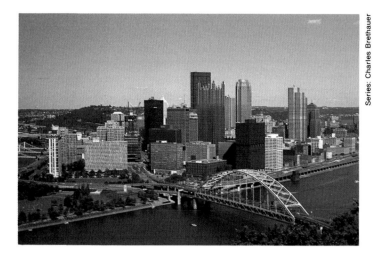

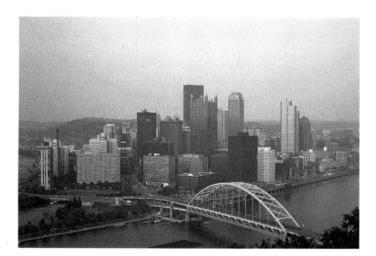

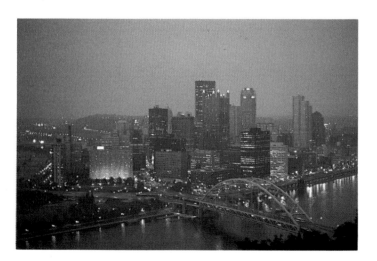

DIRECTION

Frontlighting, sun behind you, fully lights a scene. Frontlighting diminishes shadows, depth, and form, and stresses color, detail, and shape. The most common and mundane of the lighting directions, it mimics the way we see in that it fully reveals a landscape.

Off to the side, the sun strafes the land. Textures roughen, forms emerge, shadows stretch. *Sidelighting* invigorates landscapes, makes them palpable and three dimensional.

With *backlighting*, the sun behind the land and facing you, shadows determine the mood. They obscure the faces of mountains, trees, and buildings. They elongate toward the camera to exaggerate depth. Small shadows from pebbles, sticks, and grass heighten contrast.

COLOR

Though we may not always take note of it, the color of light changes perpetually from the rosy sprays of dawn to the turquoise and tangerine glimmerings of twilight. Because the mind clings to predictable associations with color, it's easy to use the color of lighting to manipulate emotions.

The coloration of light is most obvious early and late in the day, when the low slanting rays of the sun bathe the land in a placid amber light. This is the light for re-enforcing the stillness of a sleepy neighborhood or the warmth of an awakening meadow. Conversely, the indigo of twilight or the sleepy blue of an overcast day casts a pall over the land. Use the cooling qualities of such light to enhance the loneliness of a deserted beach or the desolation of an empty train platform.

When the color of light isn't exactly what you want, you can manipulate it subtly with KODAK Color Compensating Filters. These gelatin filters are available in red, green, blue, magenta, yellow, and green—from a wisp of color to medium density.

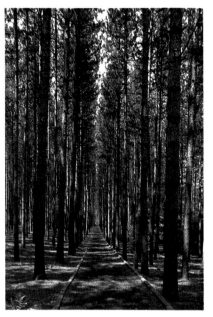
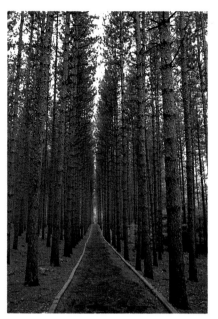

Left, direct sunlight produces deep shadows that can obscure and confuse. **Right,** diffuse light, nearly shadowless, reveals the full content of the scene.

QUALITY

Early in the day when the sky is hazy and the sun is low, the lighting is soft and inviting. Later as the sun peaks in its arc and the haze has melted away, the lighting becomes stark and glaring. This hardness or softness is called lighting quality. The size of the light source largely determines the lighting quality; the larger the source, the softer the light. Sunlight, a relatively small point source of light, illuminates scenes with hard directional lighting. But cover that light with a layer of diffusion (a cloud, for instance) and the lighting becomes softer. Light is especially soft on overcast days when the whole sky becomes a dome of diffusion. Light is also softer early and late in the day because the sun's rays have to travel through a greater distance of atmosphere.

Hard lighting can be very dramatic, giving scenes a vibrant, electric atmosphere, but it can easily overwhelm some subjects. In bright light, bold colors clash for attention. Tonal contrast strains the capability of film, masking detail in deep shadows or bleaching out highlights.

Hard lighting works best with simple landscapes, where shadows define shapes and textures. Because of its high contrast, hard lighting forces you to make difficult exposure decisions that often sacrifice either highlight or shadow detail. With slide film, you normally expose for highlights, letting shadow areas go nearly black so that the overall slide doesn't appear washed out. With negative films, you normally expose for midtones and the film's greater latitude preserves some (and loses some) detail in both shadows and highlights. With black-and-white negative film, you can hold much detail in both highlights and shadows by using the Zone System. Base exposure on a shadow area to hold its detail, then lessen development to retain highlight detail.

Soft lighting, quiet and romantic, whispers with muted colors and subtle tones. Soft lighting models subjects to show form without the distraction of harsh shadows. It also yields gentler contrasts and more manageable highlights, providing little frustration in figuring exposure.

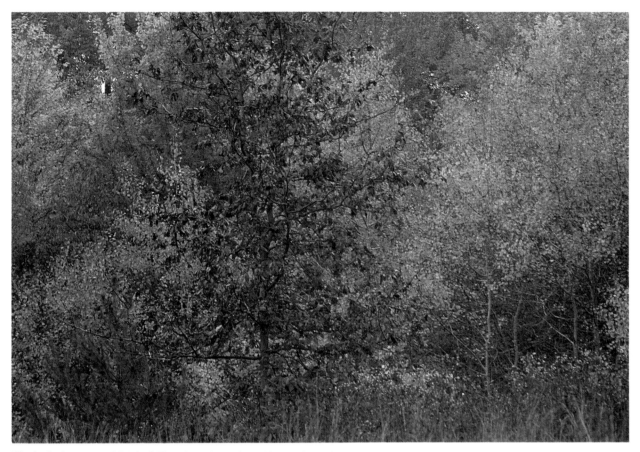

What's the best type of lighting? That depends on the subject and your intentions. **Top,** only the soft lighting of an overcast day could reveal the subtle hues in this autumn scene. **Below,** and only hard sunlight could represent the harsh environment in which Utah's Twin Mittens were carved out.

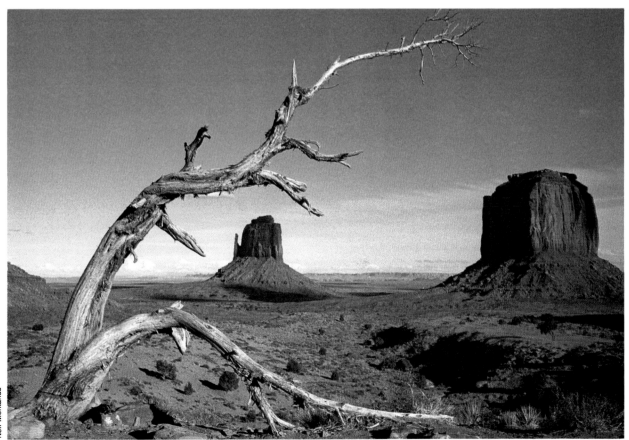

Neil Montanus

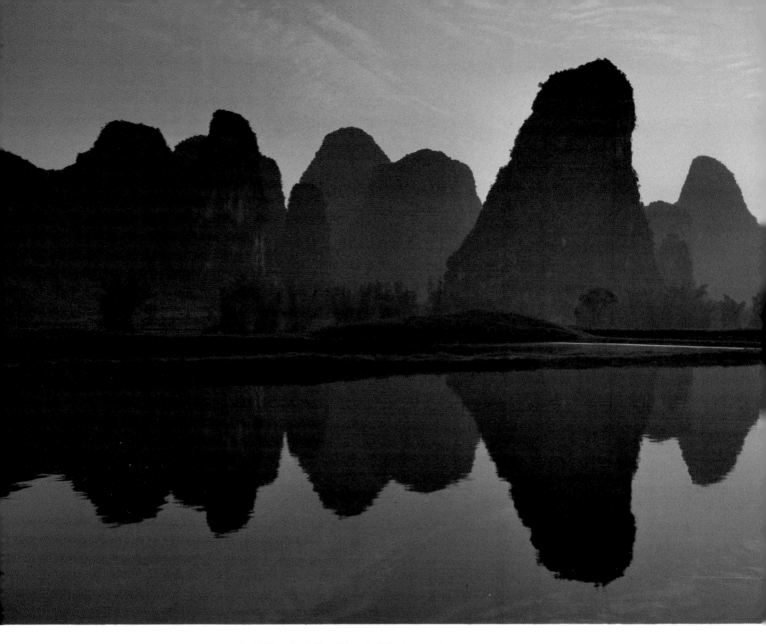

These unusual hills are along the Li River in Guilin, China. Kodak photographer Norm Kerr used a Linhof Technorama camera with a 90 mm lens.

THE DRAMA OF SUNRISE AND SUNSET

For sheer dramatic beauty, few subjects can rival the glamor of a spectacular sunrise or sunset. The colorful pomp and fanfare that surrounds the appearance and disappearance of the sun elicits strong emotions.

You can usually improve these pictures by composing them around some simple foreground subject in silhouette—a gnarled tree limb, a skyline, a rock butte. Reflecting the sky, the still surface of water also adds interest.

Meter sunsets and sunrises carefully. If you plan to include the sun in the photo, exclude the sun from the viewfinder when taking a meter reading. If you don't, you'll end up with a correctly exposed photo of the sun with everything else nearly black. Instead, meter from a bright area of sky to the side or above the sun, being careful to keep the sun itself out of the frame. If the sun is behind a cloud or foreground object, take a meter reading from any area of bright sky. In scenes where the foreground is important, tilt the camera downward away from the sky to take your initial

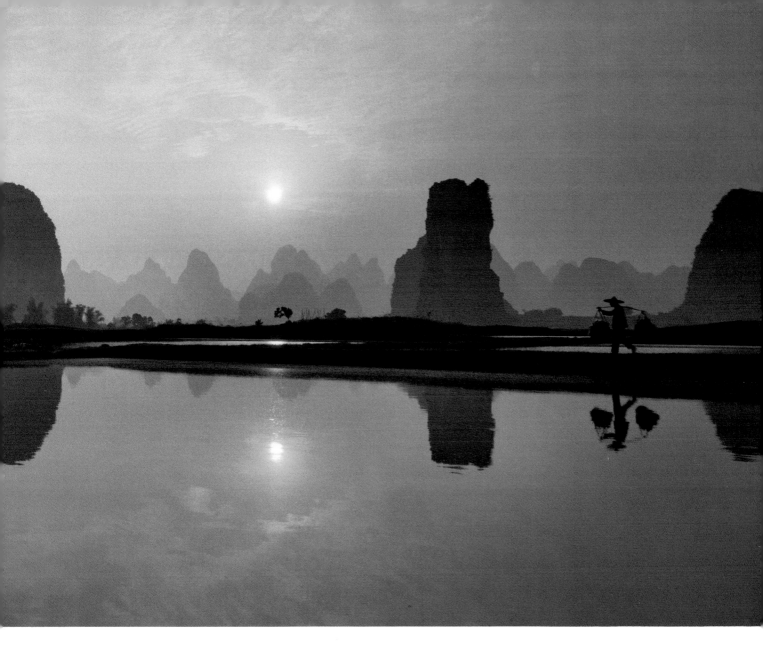

reading. You may, however, want to compromise between a ground reading and a sky reading to retain some of the sky's intensity. With slide film, underexpose 1 or 2 stops to deepen colors.

In any case, bracketing exposures, both over and under the recommended setting, will provide you with an interesting range of sky colorations and moods to choose from.

Although the sun may look immense, a normal or wide-angle lens will shrink it into insignificance in the final picture. Unless you're intent is to take in a broad sweep of land or sea,

use a telephoto lens to exaggerate the size and fiery intensity of the sun. Using a lens in the 200 to 400 mm range will recreate the scene closer to the way you remember it. In planning your shoot, remember too that some of nature's finest displays of color occur in the half hour or so preceding sunrise and following sunset. And don't get so wrapped up in shooting what's in front of you that you neglect to turn away from the sun and see its effect on the land behind you. Golden rays of a setting or rising sun can work a very special magic on the face of the landscape.

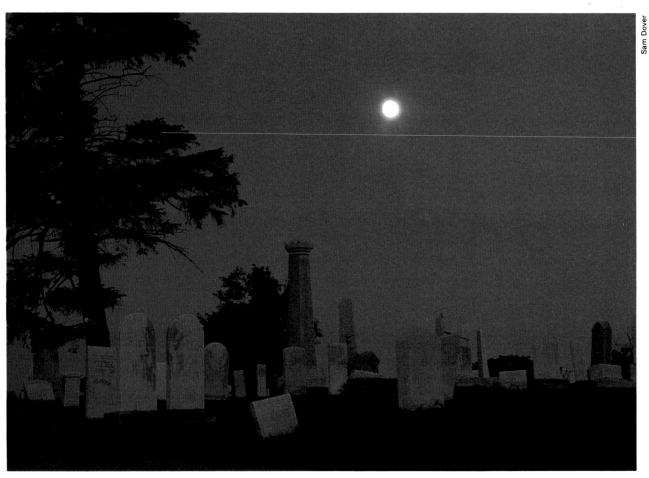

By photographing the moon at twilight, the photographer was able to make one exposure suffice for both moon and land (1/8 sec, f/8, KODACHROME 64 Film). If the moon is in the wrong position or the sky has grown too dark, you may have to make a double exposure.

NIGHT LIGHTING

Widely ignored, the nighttime landscape in many ways is more exciting and challenging to photograph than the daylight world. Street lights, star lights, neon lights, moonlight, the myriad sources of illumination that guide us through the darkness transform everyday landscapes into lands of mystery, suspense, and imagination.

The best time to photograph moonscapes is twilight, when one exposure can work well for both land and sky. To find that best exposure, however, you should bracket. Even as darkness settles over the land, the moon receives a full blast of sunlight. It is in effect a daylight subject. However, its brightness varies with its position and atmospheric conditions. Low on the horizon, it's dimmer be-

cause its light passes through considerably more atmosphere (as does a setting sun's). As it climbs the sky, it grows brighter.

Depending on film speed and ambient light (needed for foreground detail), with the aperture set at f/8, the shutter speed for a twilight moonrise will typically range from $\frac{1}{8}$ to $\frac{1}{30}$ second. For a moonlight look, the exposure should usually be 2 to 3 stops less than that indicated by a meter reading of the foreground. Or try a reading of the sky adjacent to the moon as a starting point to begin your bracket. Exposures of a few seconds or longer will not only overexpose the moon but will cause it to elongate in appearance because it is slowly moving across the sky.

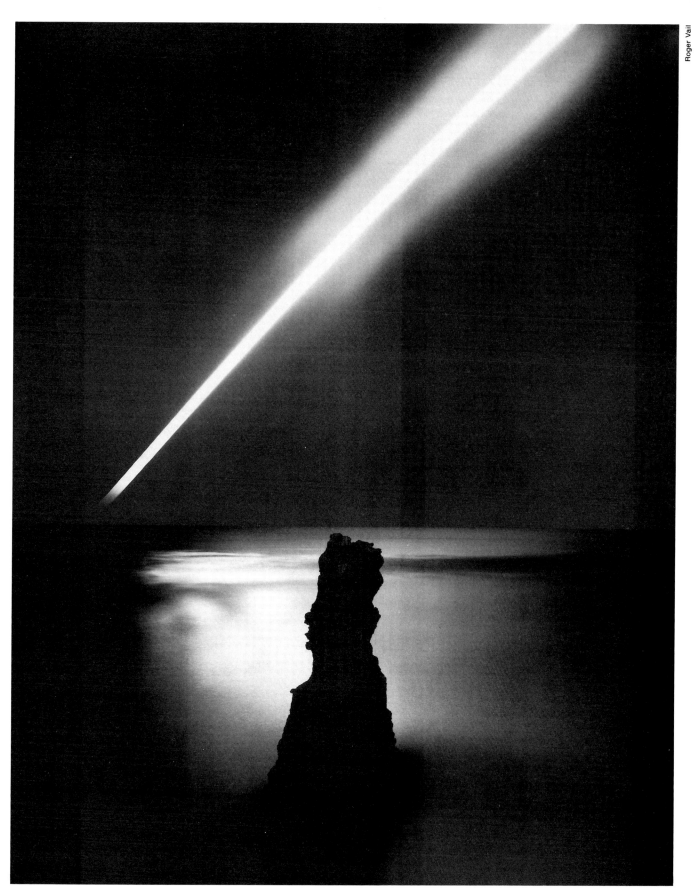

What appears to be a meteorite blazing into the ocean is actually a two-hour time exposure of the setting moon (aperture was f/16).

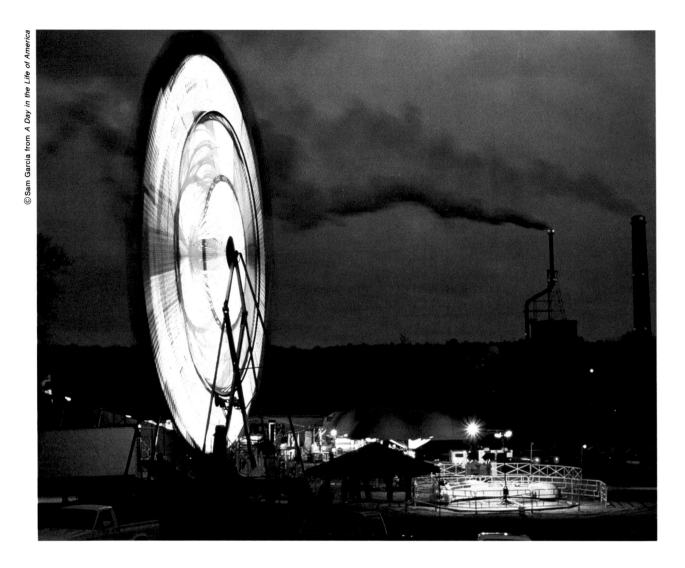

In contrast to the stark simplicity of a moonlit meadow or beach, the city at night is an electric wonderland—a universe unto itself with complex, often conflicting moods and personalities. While some may find the after-dark world festive and exotic, others see it as imposing or sinister. One way to explore your interpretation of a city's nighttime character is to experiment with a variety of vantage points.

Shoot at street level to capture the spinning kinetic rhythms of the night-time beat on the human level—the chanting flashes of neon, the garish glare of glittering marquees, the whirring streaks of traffic. Or work from the rooftops and witness an entirely different city—a distant storybook land of fantasy and mystery, of thousands of twinkling lights and the silent aura of the streets below. Photographed at night, a city appears neat, clean, and picturesque.

In either case, the best time to work is in the first hour after sunset when there is just enough afterglow lingering in the sky to faintly outline the shapes of buildings, and to provide some shadow detail. After a rain is another good time, when shiny wet asphalt becomes an impressionistic mirror reflecting back the colorful glitter and sparkle of the urban night.

Because city lights come in so many types and intensities, it's impossible to control or accurately predict the color balance of a scene. Instead, forget about correct color balance and choose one film (such as KODACOLOR VR-G 400) and let the lights paint their own color scheme.

Don't be shy about experimenting in other ways, either. If there's a lot of traffic, let the motion become part of the scene. Use long exposures of 20 or 30 seconds to turn taillights and headlights into trails of red and yellow and white. On a cool night, breathe lightly on a skylight filter and use the condensation to turn the cityscape into a romantic soft-focus illusion.

The bright, cheerful colors of a carnival ride contrast with the gloom and drudgery of smokestacks in the background.

Top, to photograph Toronto's city hall, the photographer used KODAK EKTACHROME 200 Film and bracketed exposures, and then chose the best shot. If you use a color negative such as KODACOLOR VR 1000 Film, you won't have to bracket exposures because of the film's wide latitude. **Bottom,** to create this shower of lights, the photographer panned the tripod-mounted camera downward halfway through a time-exposure of the city.

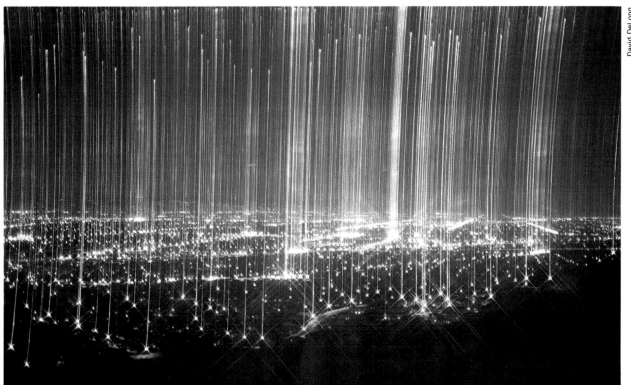

Weather on Land

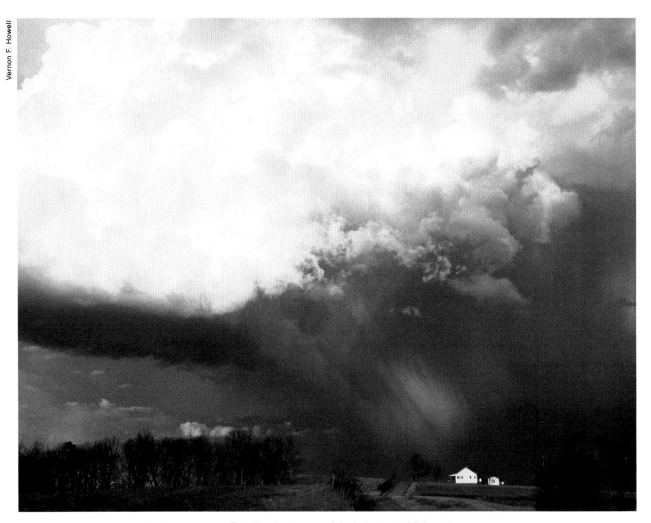

Vernon F. Howell

Nowhere does nature display her fickle temperament as readily as in her sudden, often extravagant, changes of weather. From the brooding, sullen rumblings of a summer thunderstorm, to the pristine magic of a new snow, changes in weather can transform ordinary scenes into wondrous landscapes. And with each change comes a new and special blend of beauty, drama, and atmosphere.

Extremes of weather move us emotionally, often piercing to the heart of our most primal emotions and passions. Different elements of weather elicit a wide range of emotional responses: fear, elation, gloom, anxiety, awe, hope. However you interpret a scene, go with the emotions that you feel strongest about and look for ways to strengthen their appeal.

Remember that emotional responses may be quite personal and unique—others may not always share the interpretation that you had sought or planned for.

Top, like the cartoon of the beleaguered little man pursued by a lone thundercloud, this house seems to be the sole sufferer of a torrential downpour. **Bottom,** the bright bar of clearing at the horizon reveals a distant downpour. The overall darkness establishes a somber mood.

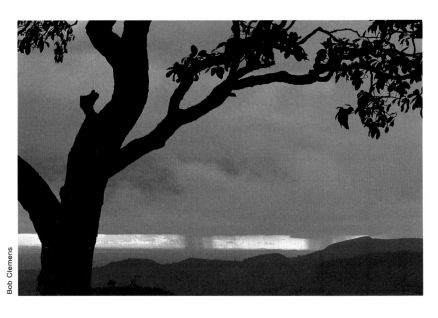

Bob Clemens

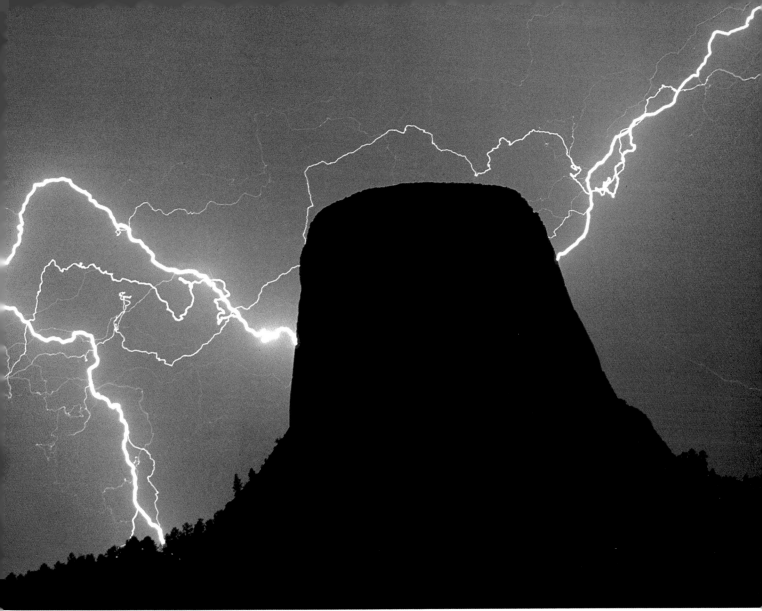

To capture forks of lightning sparking through the sky, use a time exposure of several seconds as explained in the text.

THUNDERSTORMS

Blackening skies, torrents of rain, and shrieking bolts of lightning symbolize power and destruction, even doom. Lightning can be a terrifying and dangerous subject. The key to photographing lightning is distance. From a distance, you can embrace an expanse to include lightning bolts as well as the land beneath them. From a distance, you can show a thunderhead swelling above the plains or rearing above a becalmed harbor.

From a distance, you're also safe. Successful lightning photography usually relies on a tripod, which might well function as a lightning rod. Exercise all the well-published safety rules about lightning. Go indoors or into a car when the storm is within a few miles. Don't stand in open areas. Don't stand under the tallest tree. The safest place to position yourself for lightning photography is indoors next

to a window or inside a station wagon or van with the back lid opened. Even then, once the storm is at hand, if you value your life more than a photograph, move away from the windows.

Photographing streaks of lightning is tricky because you can never predict exactly where or when they will strike. You can increase your odds by covering a wide expanse of sky with a wide-angle lens and by using as long an exposure time as possible. For daylight photography, use a low- or medium-speed film (KODACOLOR VR-G 100 Film or KODACHROME 25 Film). Unless you have a definite need for slides, use negative film since it has greater exposure latitude. Using a tripod and a cable release, set the aperture to approximately f/11 and use the shutter speed recommended by the meter (often several seconds). On some cameras you may have to

set the shutter dial to B and lock the cable release open to obtain a long exposure.

Aim the camera at a particularly active area of sky, and release the shutter the instant a streak appears. It's unlikely your reflexes will be fast enough to catch the first streak you see but any following it will be caught.

Things get easier at night. You can make a time exposure of several minutes without the worry of overexposing the film. Use a medium-speed negative film, such as KODACOLOR VR-G 200 Film. Set the shutter dial to B so you can hold the shutter open for a time exposure. Set the aperture to about f/11. Using a locking cable release, keep the shutter open for up to 5 minutes or until enough streaks of lightning have accumulated during the exposure.

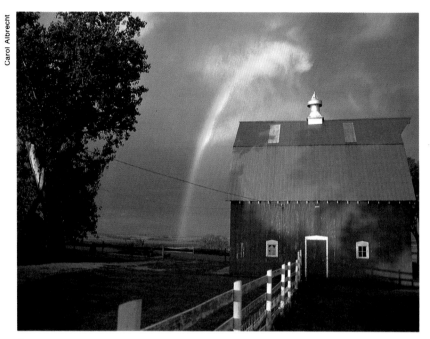

Happenstance plays a big part in the appearance of rainbows. But preparation determines your success in photographing them.

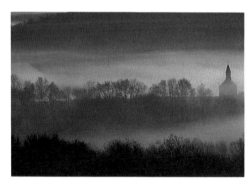

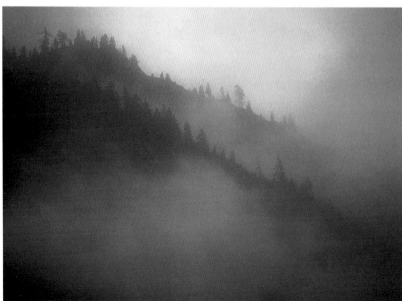

Mists are somewhat predictable. They gather in valleys during cool, humid nights. Arrive before dawn and find a high vantage point that places you above the mist. Bring a telephoto lens to isolate distant churches, barns, or trees against the mist.

RAINBOWS

Colorful, delicate, transient—rainbows symbolize resurrection and renewal and are simply delightful. Among the most fleeting of nature's prizes, rainbows can vanish as quickly as a cloud can slide over the sun. Act quickly to capture their fleeting beauty. For slide films, set exposure about $1/2$ stop lower than indicated by a meter reading of the surrounding sky (with negative films use the exposure indicated by the meter). Use a polarizing filter to enhance the colors—you can see the intensity of the bands of color change as you rotate the filter. View the scene carefully before shooting, rainbows are, after all, made up of tiny reflections and in the wrong position, the filter could erase rather than enhance your treasure.

The relative rarity of rainbows, and the excitement the accompanying storm generates makes the sighting of a rainbow thrilling. However, as with lightning, a photograph of a rainbow arcing across an empty sky will generate as much thrill as a lone wiener set before you on a dinner plate. Plan ahead for rainbows. Where in your neighborhood is an open area to view a rainbow? What in your neighborhood would complement a rainbow? A fence, a playground, a basketball court, a wet and glimmering road are all possibilities.

FOG AND MIST

Fog and mist supply mood and atmosphere. They paint the land with mystery and romance for some, with despair and melancholia for others. Whether you're photographing an early morning mist rising from a mountain valley or a dense sea fog rolling across a remote Maine harbor, fog and mist steal colors, disguise shapes, and diffuse textures. In photographing such scenes, look for patches of bright colors or bold dark shapes shouldering through the silvery veil.

Exposure for foggy scenes is usually difficult because, as with sand and snow, the light meter tries to reduce the highly reflective mist to a medium-gray. If possible, take a meter reading from a gray card to determine exposure, or open $1/2$ to $1 \ 1/2$ stops over the meter's reading from the scene (f/8 to f/5.6 or $1/125$ to $1/60$ are one-stop increases). When in doubt, bracket.

SNOW

Fields with freshly fallen snow, crystal expanses of frozen lake, tall cliffs hung with icicles—winter is more than dropping mercury and icy winds. Your interpretations of winter scenes can vary widely—depending largely on the subject or the overall scene. Without hikers, a snow-swept forest trail may seem fresh and renewing, perhaps even pastoral. But add some weary hikers trudging up the same snowy path and the mood may shift to one of struggle, endurance.

To capture the soft, fragile texture of fresh snow, look for side-and back-lighted scenes. Cross-lighting adds shadowing and form to snow drifts, and increases overall contrast, which is generally low in snowy scenes. Because it's highly reflective, snow picks up a blue tinge from the sky. The tinge is usually moody and desirable. When it seems offensive, use a 81 series filter to reduce it. In populated areas, work early in the day before footprints and car trails destroy the pristine quality of a scene.

Photographed under diffuse light, snow loses its sparkle. It turns dreary. The white blanket across the land appears soiled, a dingy gray sheet that needs to be laundered. If you want to spread cabin fever, gray snow works well. For the winter wonderland, stick to sunlight.

As previously mentioned, meter readings taken of snowy scenes will result in underexposed pictures unless you increase exposure 1 to 2 stops.

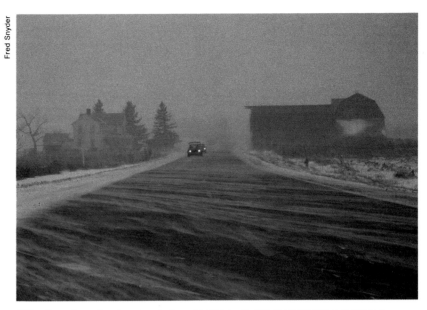

Fred Snyder

With a bag of sand and a shovel stowed in the trunk, the photographer set out in a blizzard to make this picture. With the camera mounted on a tripod, the photographer used a 35 mm lens and a shutter speed of 1/15 second to show the snow snaking across the highway.

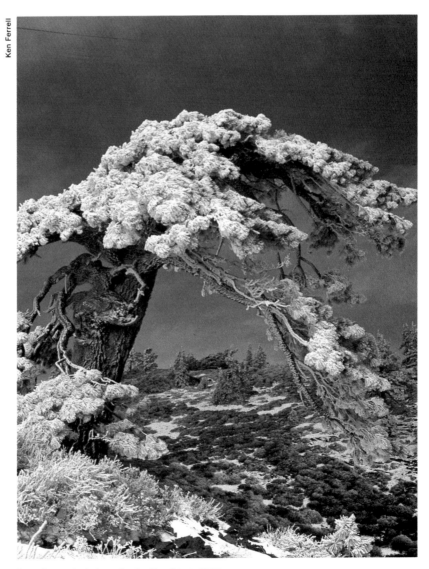

Ken Ferrell

Snow is most photogenic shortly after a storm.

PROTECING EQUIPMENT IN THE EXTREME ENVIRONMENT

It would be nice if you could make all of your landscapes in calm, inviting environments on lazy sunny days. But exciting photography doesn't come that easily. Nature exhibits her greatest dramas only to those willing to meet her greatest extremes. Extremes of punishing heat and cold, of miserable wetness, and of brutal terrains—these are the challenges that nature sets before the photographer. Learn to anticipate them, to guard against them and you can meet the challenges and revel in the rewards.

Humid Heat

Whether you're canoeing the Florida Everglades or hiking the rain forests of Malaysia, the combination of intense heat and high humidity can be an oppressive and difficult presence for both you and your equipment.

For the tourist spending only a week or two in a tropical area, high humidity usually doesn't present a problem. But with prolonged use in very humid environments, camera mechanisms may begin to rust or corrode and electronics may malfunction. Lenses may fall victim to fungus growth that can destroy the lens coating or adhesives between lens elements.

To keep camera and lenses cool and dry under such conditions, place them in a tightly sealed camera case. Aluminum travel cases with rubber seals offer the best protection for long term exposure (a tightly closing picnic cooler will make a good temporary case). Insert individual pieces of equipment into self-locking sandwich bags (squeeze out the air) with packets of silica gel (or other desiccant) to absorb moisture—especially if you'll be opening and closing your camera case frequently.

If equipment does become damp from exposure and begins malfunctioning, remove the film and air out the camera in the midday sun when humidity is lowest. Then repack it in sealed bags with fresh silica packets. Many professionals traveling to humid locations bring a portable hair dryer to give equipment a gentle but thorough drying in their hotel rooms after a day's shooting—a trick you can borrow at home or when travelling. Be careful not to accidentally blast air at the fragile shutter curtain.

The combination of heat and moisture can slow film speed or alter the color balance of color films. In extreme cases, the film emulsion may swell and stick to itself in its canister, or jam in the take up spool of the camera. Fungus may grow on the gelatin base of the film, showing itself as uneven splotches or discolorations in the final print or slide.

In humid climates, keep the film in its sealed packaging until you are ready to load it in the camera. Reseal exposed film in the plastic canister and process as quickly as possible. Keep extra film refrigerated, or, if travelling, in an air-conditioned hotel room. Taking a camera from an air-conditioned room to the hot, humid outdoors may result in condensation forming on lens surfaces and film. To prevent condensation, seal the camera in a plastic bag (squeeze out the air) before going outside. Now it can warm up gradually. After ten to fifteen minutes, you can remove and use it.

Dry Heat

A less onerous opponent than humidity, dry heat can still unloose its wrath on camera and film. In direct sunlight, the temperature of a black camera body can rise to 140°F. At such temperatures camera lubricants can migrate and optical cements may soften. At slightly higher temperatures, electronic systems may fail and batteries may leak. Only a few hours of high temperature can alter the color balance of film. To avoid the effects caused by high temperatures:

1. Never leave your equipment or film in a car parked in the sun. On a sunny day, the temperature in a closed car may soar to 140°F. If you must leave your gear in a car, put it on the floor and cover it with a white towel. Park the car in the shade. Avoid the trunk—it's the hottest part of the car.

2. Keep your camera bag in the shade as much as possible—the difference between direct sunlight and shade can be as much as 20° or 30°F on a hot day. In sunlight, drape a white towel over a dark-colored camera bag to keep its contents cooler.

3. Whenever possible, work early or late in the day. Cooler temperatures will give you fewer problems to worry about, allowing you to concentrate on your work instead

All-weather cameras are a reasonable alternative when bad weather could damage your more expensive equipment.

of babysitting your cameras. Whether you're shooting in the deserts of the Southwest or the streets of Manhattan, temperatures soar quickly in the late morning hours—what may begin as a pleasurable experience can become an ordeal by sunlight.

4. Wind film slowly and avoid using a motor winder—the static caused by rapid winding (or rewinding) may leave permanent marks on the film.

5. Use a white Styrofoam picnic cooler as a temporary camera case for beach or desert shooting. Styrofoam is cellular in structure and creates a dead air space around the interior. Use a sealed, refreezable refrigerant (wrapped in a towel) for added cooling.

6. To keep yourself cool when working with a view camera, buy (or make) a focusing cloth that's white on one side and black on the other. White and black cotton material sewn back-to back works well. The black side keeps reflections off of ground glass, the white backing reflects an enormous amount of heat.

7. Keep out sand and dust. They can scratch lenses and jam camera and lens mechanisms. When sand and dust pose a threat, use duct tape on the camera to seal joints and hinges, as well as the lens mount. Protect the lens with a UV, haze, or skylight filter. In extreme conditions, use a plastic bag or underwater housing. After each session, blow and then brush away particles from the exterior and interior of the camera.

8. Wear sweat bands on wrists and forehead to keep perspiration from dripping onto (or into) your camera. Sweat is salty and corrosive. Wear a visor to keep sun off of the viewfinder when you're shooting (and prevent sunburn when you're not).

At the Shore

Water, sand, and salt are an awesome trilogy of destructive power. Combined with an ever present wind, you have a camera repairman's nightmare in the brewing.

Salt, a powerful corrosive whether it's in the form of a wind-blown spray or a damp sea air, can quickly penetrate the seals and gaskets of cameras and lenses. Keeping the equipment dry and protected is imperative. On relatively calm days you can get away with keeping your camera in a leather ready case or under your jacket. In blustery conditions, use better protection. A plastic bag with a hole poked out for the lens will serve temporarily; a better solution is a water-tight housing.

To protect the lens from windblown sand, attach a UV or skylight filter, and keep a lens cap over the filter when you're not shooting. If spray or mist accumulates on the filter, wipe it off just prior to shooting and cover it again immediately afterward. Remember to remove and clean the filter when you're back in a dry environment. Clean both lens and filter threads to prevent salt corrosion around metal parts.

Always avoid changing film or lenses where sand or spray might enter the interior of the camera—and always dry your hands before touching equipment. If you have to open your camera and can't find a dry protected spot, hunch over your equipment with your back to the wind (or sea) and use an open jacket to protect your flanks. Carry a small can of compressed air or a blower-brush to remove any sand or dust from the interior or from camera controls. And, of course, all film and equipment should be kept as cool as possible to avoid the complications of intense heat (see "Humid Heat").

If salt water should splash on the camera, wipe it off immediately. You may want to carry a clean cloth dampened in fresh water (keep it in a self locking plastic bag) to wipe off the camera body and lens barrel while shooting. Always clean the camera thoroughly at the end of the day.

COLD

As temperatures dip below freezing, batteries lose strength rapidly. The more battery-operated functions your camera has, the faster the power drain. Common signs of weakening are erratic meter readings or sluggish response. The best prevention: keep your camera under your coat or parka when not actually shooting. Carry a second set of batteries in an inside pocket and switch when you notice one set getting low. (Batteries rekindle their zap when warmed, so you can swap sets at intervals.)

Several camera manufacturers also sell remote battery holders that are hard-wired to the camera or motor drive so you can keep them warm in a pocket. If possible, you might also consider doing away with the battery dependent systems entirely in cold weather and operating the camera in its manual mode using a hand-held meter for light readings.

Extreme cold can cause mechanical problems. Petroleum-base lubricants used in older cameras thicken at low temperatures, slowing shutters, jamming aperture diaphragms, or stiffening focusing mechanisms. If your winter pictures are consistently overexposed, for example, it may be a sign your shutter is hanging up (a repairman can replace the lubricants with an all-temperature lubricant, if cold-related problems become chronic). Today, however, most cameras use a silicone or Teflon derivative lubricant that remains fluid even at near-Arctic temperatures.

Another annoyance of working in cold weather is warm breath condensing and freezing on glass surfaces—especially the eyepiece of the viewfinder. The only way to avoid this is to hold your breath momentarily or breathe away from the finder while framing and focusing. To remove frozen condensation, melt it by blowing more warm air across the surface and wipe it away immediately with a lens tissue or chamois.

A related but potentially more serious situation can occur when warm, moist skin touches—and sometimes sticks—to the cold metal of a camera body. To avoid painful rips of your skin, tape all exposed surfaces with a canvas backed tape and use an oversized rubber eye cup around the viewfinder to protect eyes and eyelids.

Finally, prolonged exposure to very cold weather may cause film to become brittle and tear (especially around sprocket holes) if wound too quickly. And, as in hot dry weather, static charges may be recorded on the film in cold dry climates if wound too quickly. Wind film slowly and smoothly by hand.

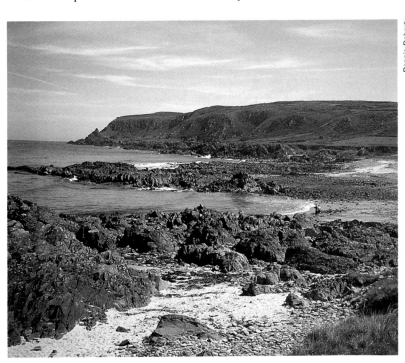

Dennis Doherty

Even on calm days at the seashore, salt mist can threaten your camera. Cover your camera when not using it to protect it from salt spray.

Cameras, Lenses, Films, and Filters

Autofocus SLR camera

SLR camera

Compact autofocus camera

Rangefinder

SLR camera

35 mm cameras come in a variety of types including rangefinders and compact autofocus models, but the most outstanding type is the single-lens reflex (SLR) camera.

CAMERAS

A lighttight box, with a glass eye at one end for looking and a piece of film at the other for remembering what it's seen—that's all a camera is.

All cameras are built upon a lighttight box. Strip away the logo, short circuit the program modes, disconnect the flashing diodes and blinking LEDS, disengage the gears and underneath its aluminum skin, there it is: the black box. But there are a lot of black boxes out there to choose from and knowing how and why they differ from one another will help you find the camera right for you.

Brand names, specific features and prices aside, cameras differ in two basic ways: format (dimensions of the image area on film) and viewing system (how the camera lets you look at a scene). Format affects both photographic quality and convenience of use. Viewing systems mainly affect the convenience of the user. Each of the different formats and viewing methods has its own advantages and drawbacks.

35 mm SLR Cameras

The smallest and most popular of the serious formats is 35 mm (image size is 24 x 36 mm). Fast, convenient, lightweight, and mercifully compact, the 35 mm single-lens reflex (SLR) camera is also versatile. Lenses, from macro to wide-angle to super-telephoto, can be interchanged at the flick of a wrist. Motor drives, remote releases, underwater housings, and a profusion of other add-ons make it adaptable to almost any shooting situation or environment.

Inside the SLR camera, a mirror and prism deflect the image formed by the lens into the viewfinder, where you see virtually the same image (within a few degrees) that the lens projects onto the film. Because most SLR lenses have an auto-diaphragm, you view the image from the lens at its widest (brightest) aperture.

Other types of 35 mm cameras are rangefinder and compact autofocus cameras. These cameras have a viewing system separate from the lens. And although they can produce fine photos, they are less often used by serious photographers because they generally lack the array of accessories available for SLRs.

About thirty years ago, professional photographers realized that improvements in film technology were so good that quality photographs could be produced with 35 mm cameras. So began the relentless march of the 35 mm SLR. Ever sharper and ever finer-grained, 35 mm Kodak films of today can produce prints that rival those made from larger format negatives. Fine-grained Kodak films, such as KODACOLOR VR-G 100, KODACHROME 25, KODAK Technical Pan, and KODAK T-MAX 100 Professional Films, yield high-quality enlargements up to 16 x 20 inches or larger.

Twin-lens reflex camera

SLR camera

Rangefinder camera

SLR camera

Medium format cameras are available as rangefinders, SLRs, and twin-lens reflex (TLR) types.

Medium-Format Cameras

On the next step up the format ladder are the medium formats. Medium-format cameras actually comprise a group of several different image sizes including: 6 x 7 cm, 6 x 4.5 cm and 6 x 6 cm, all achievable on 120 film, depending on camera configuration. The principal advantage of using a medium-format camera is that its larger negative size (about four times the area of a 35-mm frame), yields higher quality prints than those from 35 mm negatives. The higher quality results because medium-format negatives require less enlargement. To make an 8 x 10-inch print, a 6 x 7-cm negative is enlarged 4x. A 35 mm negative is enlarged 8x, or twice as much. The main disadvantages of medium-format cameras are higher cost for comparable equipment and greater weight, an important consideration for landscape photographers lugging gear up a trail.

Medium formats also come in several viewing styles, the predominate one being an SLR design. In some SLR types, the viewfinder is replaced by a viewing hood, which displays the image (reversed left to right) on a focusing screen. Another viewing system, popular on earlier medium-format cameras, is the TLR (twin-lens-reflex). It uses two identical lenses, one that provides an image for viewing and focusing and one that projects the scene onto the film. This causes an occasional parallax problem, where for pictures taken at a close distance, the image-forming lens sees a slightly different area of the scene than the viewing lens. A lot of good used as well as new TLR models remain on the market and can be an inexpensive first step into a medium-format camera.

Yet another viewing system is the rangefinder design similar to that found in 35 mm rangefinder cameras. Although accessory lenses are available for some rangefinder cameras, many are essentially one lens, therefore one-focal length, cameras that can restrict your versatility. With them, if your back is up against the wall while photographing a waterfall in a glen, you can't squirm free by switching to a wider-focal length lens. Nor can you leap a canyon with a telephoto lens to magnify a distant Joshua tree. If you choose a rangefinder camera, choose one that offers interchangeable lenses.

In addition to offering more image area, the medium-format SLR cameras also offer much of the same flexibility as 35 mm's, including lens interchangeability. Many also have interchangeable camera backs, which allow you to change film types in mid-roll—so you can photograph the same subject in both black and white and color simply by switching backs. As with 35 mm SLRs, medium-format SLRs offer the greatest flexibility.

Large-Format Cameras

Large-format cameras are the "big guns" of the camera world. They're often called view cameras, because you view the image sent by the lens directly onto a piece of ground glass. By most modern criteria, view cameras are heavy, ungainly, expensive, and time consuming. Yet a growing number of serious photographers—some rebelling from automation, others seeking a higher level of craftsmanship—are returning to this classic tool of the serious photographer.

View cameras are made in several formats, the two most common being 4 x 5-inch and 8 x 10-inch. (In the days before enlargers, view cameras were made to accommodate negatives the size of the finished print, sometimes 20 x 24-inches!) You buy film in sheets and load it in the dark into individual holders. After composing a scene, you insert the film holder into the camera and take the picture. Such large negatives provide an unparalleled clarity and richness of detail—but at a considerable cost in convenience.

Though they've been modernized in some details, the view cameras in use today are remarkably similar to those used by the first landscape photographers more than a century ago. Basically, a view camera consists of a front standard (it holds the lens) and a rear standard (it holds the ground glass and film) that are joined together by a folding bellows (an adjustable black box) on a bed.

The type of bed or track on which the standards "ride," differentiates between the two main styles of view camera. Those that travel on a metal tubular arrangement are called monorail cameras. Those that use a rectangular wooden frame as a track are called flat-bed cameras. Because flat-bed cameras often have a folding capability (making them more portable), they are frequently referred to as field cameras.

Both monorail and field cameras allow the film and lens planes to be independently adjusted (both laterally and vertically, on both the vertical and horizontal axis) within the limitations imposed by the bellows. These movements offer a far greater degree of image control than any other type of camera. By raising, lowering, shifting (side to side) or tilting (forward or back) either lens or film plane (or both), you can correct (or create) distortions in perspective, control the shape of objects or maximize depth of field.

Of the two types of cameras, field cameras are better suited to most landscape work simply because they're more compact (you can easily tote a 4 x 5-inch model in a backpack). On the other hand, monorail cameras generally offer a greater degree of flexibility in camera movements—very useful in providing correct perspective of buildings, trees, etc. Monorail cameras are usually of a more modular design also, offering a greater range of available accessories.

Whatever type of view camera you choose, you'll be carrying more than a camera and lens into the field. In addition to film holders, you'll need a handheld light meter, a focusing cloth (to keep external light off the ground glass while you frame and focus), a magnifier to help focus the image, and a sturdy tripod to support the camera. Although setting up and using a view camera becomes second nature in time, it takes a devoted and well-conditioned photographer to haul one up a snowy slope in January or across a hot beach in July.

Why would anyone put themselves through such an ordeal? The answer is image quality. But for many photographers, the mere act of composing a picture with a view camera takes on a special significance. The view camera brings out an element of patience and carefulness in photographers that often gets overlooked in the click-click world of smaller formats. Read what Ansel Adams wrote in his classic book *The Camera:*

> *Although my mind assures me that I should be able to visualize a fine image no matter what camera I use, I find a particular conviction and pleasure in viewing a large view camera image on the ground glass. These images are a delight to behold, even if no photograph is made!*

With the lens removed, a field view camera folds into a fairly compact unit that weighs only a few pounds.

84

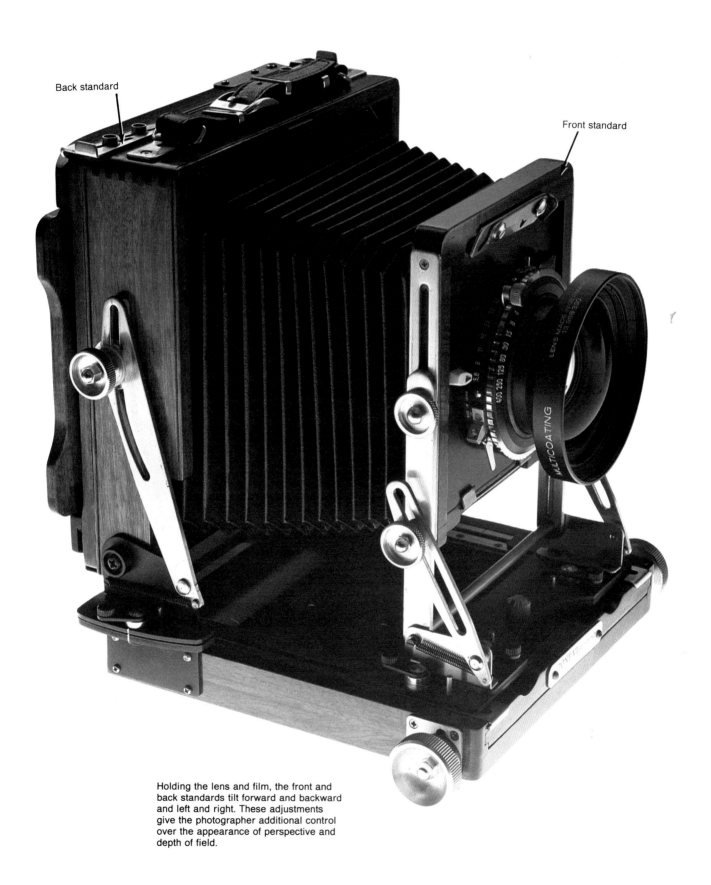

Back standard

Front standard

Holding the lens and film, the front and
back standards tilt forward and backward
and left and right. These adjustments
give the photographer additional control
over the appearance of perspective and
depth of field.

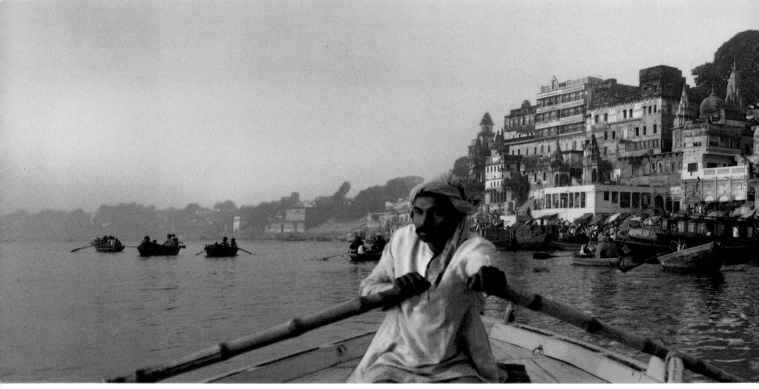

In a boat on the Ganges at Varnasi, India, Kodak photographer Steve Kelly used a Tomaiyama Art Panorama camera to take this photo (see text).

The Panon Widelux camera, shown here, uses 35 mm film.

Panoramic Cameras

The desire to record in a single photograph everything the eye can see with a turn of the head has haunted the imaginations of photographers since the very invention of the camera. And the early photographers, reveling in the boundless potential of a brand new medium, wasted little time in solving the technical riddle of panoramic photography.

In fact, it was in 1844, only five years after Daguerre introduced the daguerreotype process to the world (the first readily available photographic process) that the first panoramic camera was invented. Its inventor, Friedrich von Martens, designed and built a camera that took in a 150-degree angle of view on a single 5 x 15-inch curved daguerreotype plate. The camera worked by pivoting a lens so that the image (confined to a thin slit) arced across the curved film plane.

Though the concept of panoramic photography continues to stir the creative energies of some photographers, panoramic cameras have never really garnered any large-scale popularity—partly due to their limited range of usefulness. The most practical use that was ever found for them was in photographing large groups of people—class portraits, banquets, etc.

There remains today, however, a devoted, albeit small, group of photographers who continue to pursue the panoramic landscape.

Several models of panoramic cameras are currently being manufactured, in both the 35-mm and medium formats. These cameras are able to take in extremely wide angles of view, ranging from about 140 to a full 360 degrees. Because they work on a different optical principle, they are able to take in sweeping scenes without the inherent distortion that would normally accompany an equivalent wide-angle view.

True panoramic cameras work in one of two ways. Some, like von Martens' early model and several modern ones, work by pivoting the lens on its vertical axis past a curved film plane. When you press the shutter, the lens swings from left to right, exposing the film. By using a slit to crop the lens' image, only a tiny vertical stripe of information passes over the film—which keeps distortion to a minimum.

In other cameras, the film is pulled past a stationary slit and the camera itself revolves (usually by electronic motor). This is the principle behind most 360-degree panoramic cameras. For the effect to work, the synchroni-

zation between the motion of the camera and the speed of the film has to be calibrated exactly—otherwise the image would just be a hopeless blur.

Almost all non-view panoramic cameras have a direct-vision viewfinder (a rangefinder type window) that shows an approximation of the view that the camera will capture. Exposure in most panoramics is controlled by a limited series of shutter speeds (aperture is fixed); and, if necessary, neutral density filters can be used to control light intensity.

One of the inherent faults of panoramic cameras is that horizontal lines that are parallel to the film plane sometimes appear to bend or converge to a point past the frame ends—particularly if the camera isn't exactly level. Also, objects that are near the ends of the frame will often appear distorted or elongated. Yet the amount of total distortion is negligible compared to the same scene taken with a wide angle lens of equivalent viewing angle.

One of the most popular 35 mm panoramic camera in use today is the Widelux which operates on a rotating lens basis. Using a pivoting 26 mm fixed focus lens it takes in a field of view of about 140 degrees or about the same view taken in by a conventional 17 mm ultra-wide angle lens (but without the wide angle's distortion). The camera produces a negative about 24 x 59 mm, or 14 pictures on a 24-exposure roll.

Narrower views that still look like panoramas are provided by some more conventional cameras that don't rotate the lens or move the film during the exposure. The Linhof Technorama camera is commonly used to make panoramas. With a 65 mm lens attached, it gives a viewing angle of 90 degrees and provides a $2^3/_4$ x 5-inch negative. For the picture above, a Tomaiyama Art Panorama camera was used. With a Nikkor 120 SW lens attached, it gives a viewing angle of 92 degrees.

For an extremely wide view of the world, you might consider Alpa's Roto 70—it produces panoramic views from 90 to a full 360 degrees on either 70 mm, 120 or 220 film. But a 360-degree negative (on 120 film) is 18.7-inches long, so you get only one shot to a roll (or 3 on the longer 220 format). Still, imagine the fun of showing your whole neighborhood on a single frame of film. Before you go running out to buy one, however, keep in mind the list price for this kind of fun is over $5,000.

TRIPODS

The best camera and sharpest lens that money can buy might just as well be traded for a mayonnaise jar screwed onto a shoe box if they aren't held steadily during exposure. Camera motion or "shake" is responsible for more unsharp pictures than all the poor quality lenses in the world. The best solution: a sturdy tripod.

Tripods are an essential part of landscape photography—whether you're using an 8 x 10-inch view camera (and you'd have a hard time using one without a tripod) or a 35 mm SLR. By providing total stability at any shutter speed, tripods allow you to take full advantage of all shutter speed/aperture combinations, assuring complete control over sharpness and depth of field—even in low light and with slow films. The small apertures used by landscape photographer to obtain great depth of field incur slow shutter speeds. For the landscape photographer, a tripod is not an accessory but a necessity.

The ability to make long exposures also expands your creative repertoire, by allowing you to take time exposures of moving subjects—to capture the cascading flow of a waterfall, for example. Perhaps most importantly though, setting up a tripod forces you to slow down, to take things one step at a time—giving you more of an opportunity to study the possibilities and details of a scene.

The size and type of tripod you choose will depend heavily on what format you work in, what type of environments you are likely to frequent, and how much you're willing to carry into the field. A good view camera tripod can weigh over 10 pounds, while you may be able to get away with a considerably lighter model for a 35 mm or medium-format camera. Because portability is always a consideration, choosing a tripod usually involves a compromise between heft and mobility.

As a rule, the heavier the tripod, the more stable it will be—but don't pick one so stout that you'll talk yourself out of taking it with you. At the same time, leave the mini-tripods at home. Few, if any, are sturdy enough. Weight alone does not decide a tripod's stability—design, construction, and materials are other important factors to consider.

Most tripods consist of these elements: three telescoping legs, a center post (for minor adjustments in camera height) and a pan/tilt head (for mounting and pivoting the camera). The most popular material for making tripods is metal—usually a light aluminum alloy. A few companies also offer good quality wooden models. Wooden tripods are usually lighter and just as stable as their metal counterparts, with fewer moving parts to risk jamming. Many pros swear by them.

Next to stability, versatility is the most important feature to look for in a tripod. The most basic consideration is height adjustment. Tripods range in height from tiny table-top models to full-height, eight- or ten-foot units. Those in the five- to eight-foot range are manageable, while still providing a sufficient amount of height to be worthwhile.

Choose a tripod that works well on uneven terrain. This tripod will have independently adjustable leg angles that allow the tripod to go quite low, quick-release legs, a reversing center column (for low angle work) and spiked feet (for grabbing into loose soil or sand).

Regardless of the specifics, a tripod's features are of little value if they're difficult to use or unreliable. Locking controls should hold the legs and center column tightly, without any slippage; they should not bind; and they should unlock without shredding the skin on your knuckles. Handles, adjustment knobs, and bushings should all be oversized and easy to operate, even when wearing gloves.

Unless backpacking, choose at least a medium-size tripod for its stability. Many models offer low-height support either with legs that spread out extra far (shown bottom) or with a head that attaches anywhere along the length of the leg.

The main purpose of a lens is simply to fit the scene chosen by the photographer onto the film. A wide-angle, a normal, and a telephoto lens will enable most photographers to accommodate most views.

LENSES

If there's one thing photographers don't lack for, it's a choice of lenses. If you can afford the tariff, you can cross into just about any optical wonderland that your imagination can conjure. But fortunately, if you choose your lenses carefully, you should be able to satisfy most of your needs, practical and whimsical, with but a few. The important thing is to pick lenses that match your vision of the world.

For some photographers, this means using a normal lens to capture familiar and realistic versions of their surroundings. A normal lens approximates the human view of the world, in both angle of view and apparent perspective. It reproduces the sizes and shapes of objects and the spaces between them much as we expect them to be. Many photographers prefer this conventional and natural approach to composition.

Others interpret reality through more extreme focal lengths. Different focal lengths reveal the world in different ways. The more extreme the focal length, the greater its departure from reality.

The most significant way that one lens differs from another is in focal length. In technical terms, focal length is the distance from the optical center of the lens to the film plane of the camera (the focal point of the lens) when you focus the lens at infinity. In reality this distance may not be exactly accurate because modern lens design methods often displace the physical distance between the two (some lenses being shorter than their focal length). On a more practical level, focal length determines the magnification and the angle of view of a lens. A short-focal length lens sees more but magnifies less, and a long-focal length lens sees less but magnifies more.

Wide-Angle Lenses

Wide-angle lenses offer just what their name implies—an expanded view of the world. A moderate wide-angle of 28 mm (on a 35 mm camera) takes in an angle of view of about 74 degrees (compared to about 46 degrees for a normal lens). Ultra-wide angles, those in the 15 mm range, have angles of view of 110 degrees or more. Generally, however, lenses in the 24 mm to 35 mm range are most useful and lessen the distortions associated with very wide lenses.

From a creative standpoint, wide-angle lenses offer several intriguing properties. Their inherent depth of field, for instance, combined with their close-focusing capability enables you to create dramatic exaggerations of space, distance and linear perspective.

You can also exaggerate shapes and sizes of nearby objects by working very close to them. With ultra-wide angles, distortions can enter the realm of surrealism—tall buildings become rockets and flowers become caricatures of themselves.

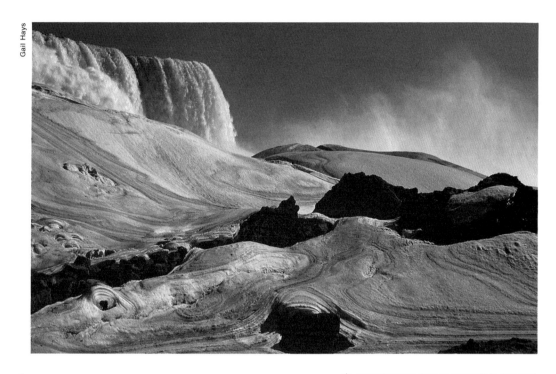

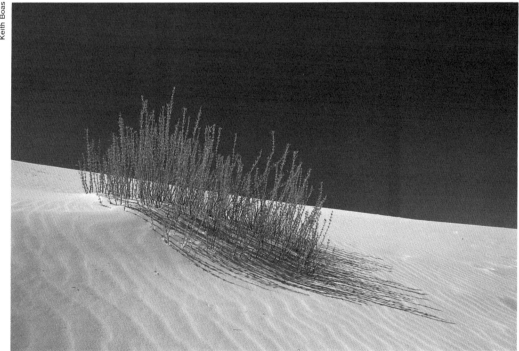

The main advantage of different focal length lenses is that you can choose the lens that matches the field of view you are photographing. Top picture taken with a wide-angle lens, bottom picture with a normal lens.

91

Telephoto Lenses

Telephoto lenses, on the other hand, see only a sliver of the world around them (a 100 mm lens sees an angle about half that of a normal lens). And rather than expand space, telephotos compress the apparent distance between objects. You can exploit this quality in several ways. With moderate telephotos (those in the 80 mm to 200 mm range), you can compress distances to establish or clarify the relationship between two or more elements in a scene—or to isolate one group of elements from a more elaborate view.

With more extreme focal lengths (300 mm or longer), you can create outlandish exaggerations of compressed space that nonetheless look quite convincing—a fiery ball of setting sun swallowing up a pair of windsurfers, a full moon engulfing the tip of the Washington Monument, an entire city skyline flattened to a single plane. Super telephoto lenses (above 500 mm) can eliminate entirely the illusion of three dimensions, turning ordinary scenes into hauntingly abstract two-dimensional designs.

There are, of course, purely practical applications and considerations for each group of focal lengths. Wide-angle lenses allow you to work in much tighter quarters and are much lighter to carry; they also have a greater inherent depth of field for a given subject distance.

Conversely, telephoto lenses allow you to photograph much more distant subjects—subjects that might be physically inaccessible. The price paid for this convenience, however, is extra weight and slower lens speed.

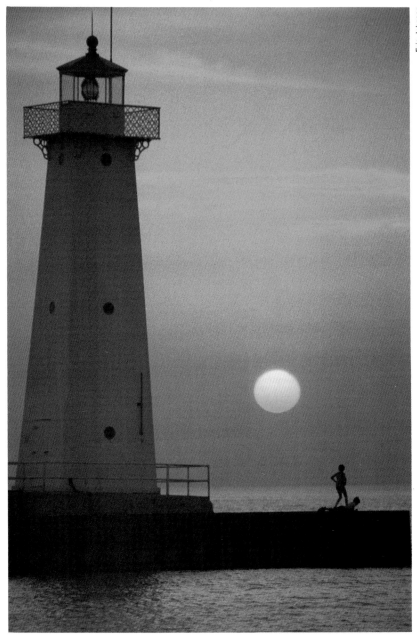

Eric Johnson

Telephoto lenses magnify scenes, in this case enlarging the sun to match one's perceptions of a setting sun. 135 mm lens used.

24 mm

50 mm

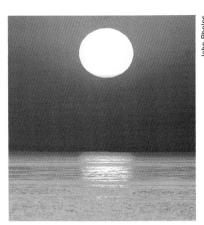

300 mm

John Phelps

Zoom Lenses

Zoom lenses offer a continuously adjustable focal length, often over a wide-angle to telephoto range. For example, a 35-200 mm zoom lens can be set anywhere between 35 mm and 200 mm. This one lens can function as a wide-angle, a normal lens, or a telephoto lens. Depending on the lens type, you alter the focal length either by turning a collar or by pushing and pulling it along the length of the lens barrel. When positioned at a steep angle, the push-pull collar may slide away from its original setting. Some lenses have a lock button to hold the collar in place.

Zoom lenses are named by their focal-length range. Some typical ranges for 35 mm cameras are 80-200, 70-210, 35-105, and 28-200 mm. The greater the range, usually the bigger the lens, and sometimes lenses with a great range aren't quite as good optically. Most zoom lenses also have a macro setting for close-up work. Zoom lenses are made for nearly all 35 mm and medium-format SLRs.

Although a zoom lens usually costs and weighs more than a single-focal-length lens, it costs and weighs considerably less than the several lenses it can replace. Modern zoom lenses are nearly as sharp as single-focal length lenses. But they are not without drawbacks. They don't focus as close as single-focal-length lenses. For instance, one 28-85 mm zoom lens focuses no closer than 3 feet while a typical 28 mm lens will focus down to 1 foot. Zoom lenses also have larger maximum apertures, typically f/3.5 or even f/5.6 for some telephoto zooms. Except for a dimmer viewfinder, a larger maximum aperture usually won't hinder the landscape photographer who often works at small apertures anyhow. Zoom lenses also often take larger (more expensive) filter sizes.

Generally, single-focal-length lenses probably remain slightly sharper than zoom lenses. But it's a difference you may have to strain to see. Although leaving behind all but one zoom lens may not tempt the landscape photographer traveling by car, the backpacker should have few qualms about hiking into the wilderness with a single wide-angle-to-telephoto zoom lens (and perhaps a macro lens).

On a "one-touch" zoom lens, left, the large knurled control adjusts both focus and focal length. On the "two-touch" zoom lens, right, separate controls are used to adjust focus and focal length.

With a perspective control lens, you can shift the front element to make vertical subjects perpendicular to the ground instead of appearing to lean back.

Perspective Control Lenses

The perspective control or "PC" lens is a specialized lens that architectural photographers often use to control the convergence of parallel lines in tall or elongated buildings. A PC lens is a wide-angle lens (usually 28 mm or 35 mm on a 35 mm camera) that allows you to shift the front element off-axis to correct for the convergence of parallel lines. Shifting the front element (either vertically or laterally) works like a rising/shifting front standard on a view camera.

By raising the front element, for example, and keeping the film plane parallel to the subject's vertical surface (instead of aiming the camera up), you can keep tall subjects from leaning back. A few PC lenses also allow a forward tilt of the front element which, again, imitates the front tilt movement that a view camera uses to increase depth of field. The cost of a 28 mm PC is about triple that of a similar wide angle without shift.

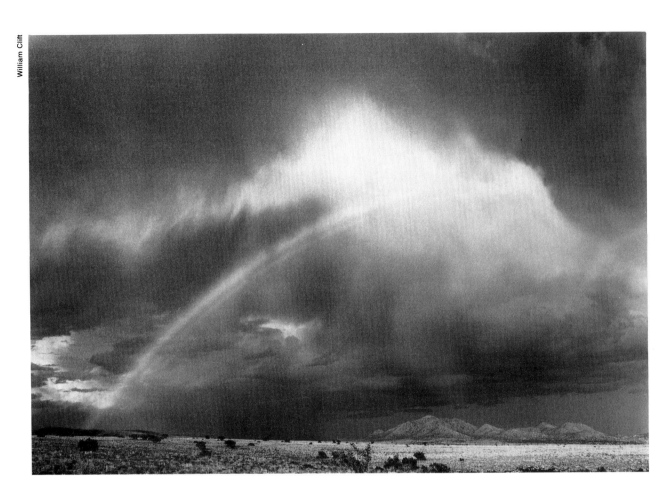

Although some scenes seem to demand color film, imaginative photographers know that no scene, even a rainbow, has to be shot in color.

William Clift

FILM

Since film is the repository of your hard work and imagination, it only makes sense that you become familiar with some of the attributes and peculiarities of its many guises. Eventually most photographers settle on one or two favored films whose characteristics match their own perceptions. But in the beginning, it's wise to experiment with several different films to see the differences among them.

First decide whether to record the world in color or black and white. For most of us, color is reality. The soft golds of the morning sun, the opulent greens of spring leaves and summer lawns, and the earthy rusts, russets and reds of autumn—these are the spice and flavor of life. Yet there are many photographers to whom colors are mere window dressing, a visual frill—to them the colors of photography are black and white.

Only you know how you see the world, only you can decide the film right for you. Some photographers, influenced by the work of others,

discover their preferences very early and pursue that path exclusively. You may too. Or you may find it challenging to alternate between colorful and colorless to match film to the subject and mood you want.

By far the more popular among amateurs, negative films account for nearly 90% of all color film sales. The KODACOLOR VR-G Films, available in speeds of ISO 100, 200, and 400, are high-quality negative films. They are especially well-suited for landscape photography because of their rich colors and extremely fine grain.

Kodak negative films have great exposure latitude—that is, they're very forgiving of exposure error. Negative films overexposed by as much as 3 full stops or underexposed by 1 stop still produce acceptable prints. Because these films go through a printing stage, moderate corrections in color balance can be made during printing (to correct for the blue tinge of an overcast day, for example).

Color slide films produce transparencies for projection. For color pictures, magazines and books rely almost exclusively on transparencies. KODACHROME Film has long been the film preferred by magazine editors. Because there is no intermediary printing phase, slide film is devoid of any color or contrast corrections. But, while you can't alter the color balance of a slide once its made (unless you dupe it), you can choose a film that leans toward a certain balance. KODAK EKTACHROME Films, for instance, provide a neutral color balance, while KODACHROME Films are warmer toned. In 35 mm and medium formats, KODACHROME Film is a favorite; KODAK EKTACHROME 64 and 100 Professional Films are also widely favored for medium- and large-format cameras.

Slide (transparency) films, however, are less tolerant to exposure error. An error of only one stop in either direction can be critical; causing highlights, for example, to burn out with overex-

94

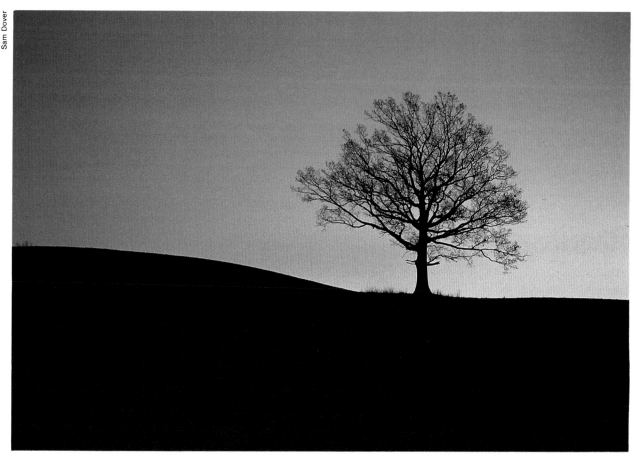

Sam Dover

Although this monochromatic scene would probably look good in black and white, color also suits it well.

posure or become muddy with underexposure.

The most difficult part of using black-and-white films is learning to see the world as they do—in a monochromatic range of grays. That black-and-white films don't "read" color with the same relative brightnesses that color films do complicates visualization of the final print. Learning to visualize how the final image will look takes practice and patience. KODAK TRI-X Pan, PLUS-X Pan, and the very fine-grained Technical Pan Films are old standbys that have given excellent results for many years. If you haven't yet tried KODAK T-MAX 100 Professional Film and KODAK T-MAX 400 Professional Film, do so. They use Kodak's T-GRAIN Emulsion technology. That means they can offer medium- or high-film speeds yet deliver negatives that exceed the quality of similar-speed conventional films and rival those produced from large-format cameras. Their responsiveness to development makes them ideal for

practitioners of the Zone System. The graininess of T-MAX 100 Professional Film is better than that of KODAK PANATOMIC-X Film, yet its speed of 100 is two and a half times that of PANATOMIC-X Film. T-MAX Professional Films are available in 135, 120, and sheet-film sizes.

Another factor to consider is film speed. Assigned to each film, a numerical rating (called an ISO number) indicates the film's sensitivity to light. The higher a film's ISO, the greater its sensitivity to light (the faster it is). Sensitivity of a film doubles as the ISO number doubles, or halves as the number is halved. High numbers are considered "fast" and low numbers are "slow."

In use, low-speed films require longer shutter speeds (or larger apertures) to provide enough light to expose the film than do higher-speed films. In results, low-speed films generally give sharper, less grainy (sand-like texture) photos than do higher-speed films.

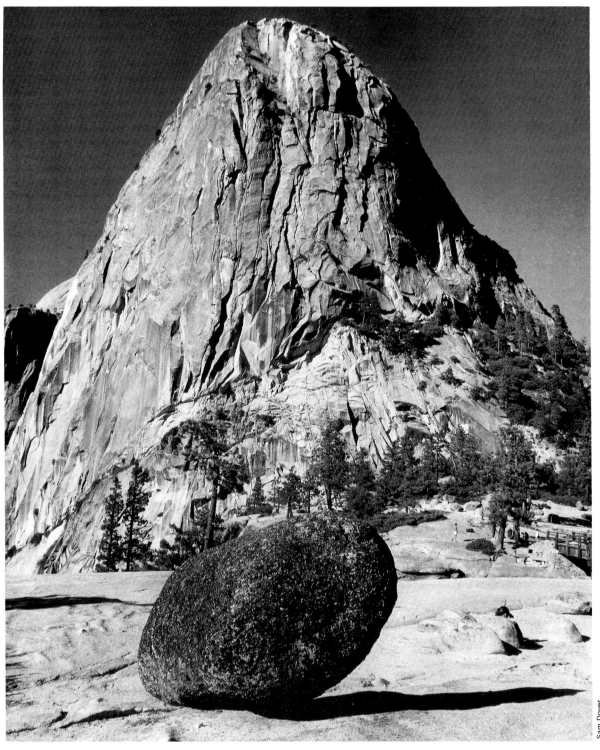

Sam Dover

For nearly grainless prints, use KODAK T-MAX 100 Professional Film. Incorporating T-GRAIN Emulsion, it's nearly twice as fast as KODAK PANATOMIC-X Film, yet gives better grain.

By convention and tradition, landscape photographers have sought near grainless images. Thus they have used either slow films, such as Technical Pan or KODACHROME 25 Film with 35 mm cameras, or they have used medium- or large-format cameras. With the larger formats, they can then use faster films and still obtain nearly grain-free images. And they nearly always use a tripod to ensure optimum sharpness.

However, convention and tradition need not dictate your photography. Accentuated graininess has its place. Depending on the lighting and subject, it can instill a gritty realism or a soft romanticism. Use a fast film for graininess. Also keep the subject small so you can later greatly enlarge it to further accentuate its graininess. For black-and-white photography, use KODAK Recording Film (speed of 1000 to 4000). For color, use KODAK EKTACHROME P800/1600 Film for slides or KODACOLOR VR 1000 Film for negatives.

Infrared Film

An unusual film that many landscape photographers like to dally with is KODAK High Speed Infrared Film. This film is quite grainy and enlargements from the 35 mm format seem soft and surrealistic. Equally-sized enlargements from the 4 x 5-inch format are considerably sharper and less grainy. The film's sensitivity to infrared radiation reveals a world unseen by conventional black-and-white film or by you. Trees turn white, skies blacken, faces pale. Whatever reflects relatively large amounts of infrared radiation will appear white or light gray when photographed. To enhance the effects created by the infrared radiation, use filters that block light, thus increasing the proportion of infrared radiation reaching the film. No. 25 red, No. 29 deep red, and No. 87 and No. 89 opaque filters are commonly used. The No. 87 and 89 filters prevent you from seeing the scene through the viewfinder when attached to SLR or view cameras.

Be forewarned that infrared film is temperamental. It needs to be loaded into and unloaded from the camera in *complete* darkness. Since neither you nor your meter make a good judge of the amount of infrared radiation being reflected in a scene, bracket exposures. On a sunny day with a No. 25 red filter attached, start at $^1/_{125}$ sec, f/11 for a distant scene. Use $^1/_{60}$ sec, f/8 for a nearby scene.

You may also have to adjust the focus since lenses focus infrared radiation on a different plane than they do light. Many 35 mm and medium-format lenses have a red infrared focusing mark just off to the side of the normal focusing index mark. Here's what you should do. Focus normally. Note the subject distance opposite the index mark on the lens. Turn the lens until this distance lines up with the infrared index. If the lens lacks an infrared index, use a small aperture (f/8, f/11, or less) and focus on the near side of the subject or slightly in front of it.

Derek Doeffinger

Sam Dover

The bizarre effects of black-and-white infrared film have long fascinated landscape photographers. Both of these photos were made on 35 mm KODAK High Speed Infrared Film, using a 24 mm lens and a No. 25 red filter. Exposures were bracketed as described in the text.

FILTERS

Filters are the fine-tune adjusters of photography. And like the fine-tune controls on a television, you can use them to perfect the color balance of a scene, correct contrast or brightness, or just have fun by changing colors or tones. Most importantly, in both black-and-white and color photography, filters allow you to match the realities of a scene to the limitations of your film.

Filters for Black-and-White Films

Black-and-white photographers use colored filters to alter the brightnesses and contrasts of tones in the final print. This is usually necessary because black-and-white films see the world differently than we do. For example, while most black-and-white films are sensitive to all colors of the spectrum (plus invisible ultraviolet),

they are not equally sensitive to all colors. Black-and-white films are particularly sensitive to the blue and ultraviolet end of the spectrum, and less sensitive to the yellow-red areas, whereas the human eye is most sensitive to the yellow-green portion of the spectrum.

The tonal relationships that exist in a print, therefore, sometimes differ disappointingly from the way that we remember them in real life. Skies bleach out, foliage darkens and dissimilar colors merge as almost identical shades of gray. Tonally the final image may bear little resemblance to the one we thought we saw.

Enter the filter. With colored filters you can regulate the color of light reaching the film to preserve, subordinate, or exaggerate the brightnesses and contrasts your eyes see. Unfil-

tered, a blue sky appears lighter than expected. With a No. 8 yellow filter (which absorbs some blue light), you can darken the sky to a tone more closely resembling what you saw. Orange and red filters further darken blue sky. Similarly, a No. 11 yellow-green filter, darkens the sky and also lightens foliage, creating a more pleasing tonal balance between the two.

The simplest way to visualize the effect of a filter on a given scene is to remember this rule: A filter lightens objects of its own color and darkens those of complementary colors. There are no right or wrong filters, it's mostly a matter of personal taste and depends largely on what type of mood you're trying to establish. The table below provides some idea of what different filters will do in a variety of landscape situations.

Daylight Filter Recommendations for Black-and-White Films in Daylight

Subject	Effect desired	Suggested filter	Increase exposure by this many stops*
Blue Sky	Natural	No. 8 Yellow	1 (²/₃)
	Darkened	No. 15 Deep Yellow	1¹/₃ (1)
	Spectacular	No. 25 Red	3 (3)
	Almost black	No. 29 Deep Red	4
	Night effect	No. 25 Red, plus polarizing filter	4¹/₂ (4¹/₂)
Marine scenes when sky is blue	Natural	No. 8 Yellow	1 (²/₃)
	Water dark	No. 15 Deep Yellow	1¹/₃ (1)
Sunsets	Natural	None or No. 8 Yellow	1 (²/₃)
	Increased brilliance	No. 15 Deep Yellow or No. 25 Red	1¹/₃ (1) / 3 (3)
Distant Landscapes	Increased haze effect	No. 47 Blue	2²/₃ (3)
	Very slight addition of haze	None	
	Natural	No. 8 Yellow	1 (²/₃)
	Haze reduction	No. 15 Deep Yellow	1¹/₃ (1)
	Greater haze reduction	No. 25 Red or No. 29 Deep Red	3 (3) / 4
Foliage	Natural	No. 8 Yellow or No. 11 Yellowish-Green	1 (²/₃) / 2 (1²/₃)
	Light	No. 58 Green	2²/₃ (2²/₃)
Outdoor portraits against sky	Natural	No. 11 Yellowish-Green No. 8 Yellow	2 (1²/₃) / 1 (²/₃)
Architectural stone, wood, sand, snow when sunlit or under blue sky	Natural	No. 8 Yellow	1 (²/₃)
	Enhanced texture rendering	No. 15 Deep Yellow or No. 25 Red	1¹/₃ (1) / 3 (3)

*Filter adjustments in parentheses are for KODAK T-MAX 100 and 400 Professional Films.

No filter

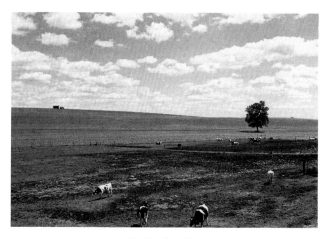

No. 8 yellow filter

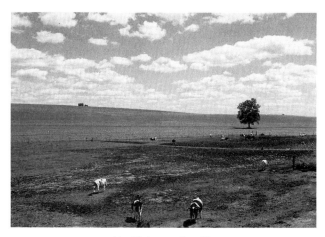

No. 15 deep yellow filter

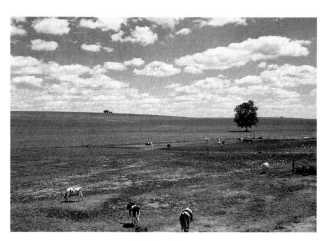

No. 25 red filter

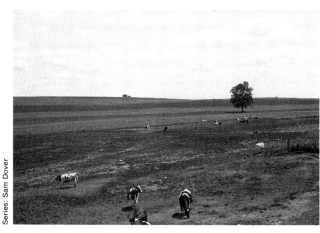

No. 47 blue filter

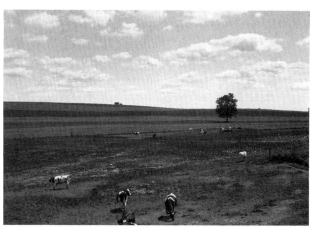

No. 58 green filter

To alter the tonal rendition of the sky in black-and-white photography, use colored filters. The No. 8 yellow, No. 15 deep yellow, No. 58 green, and No. 25 red filters increasingly darken a blue sky, making the clouds stand out by contrast. A No. 47 blue filter lightens the sky.

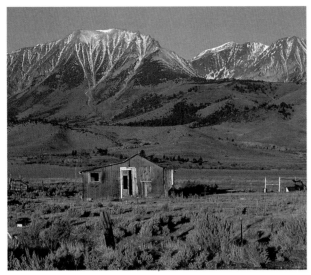

No filter

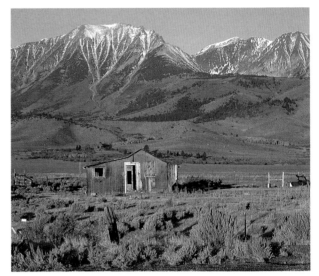

82A filter

Left, light is more yellow when the sun is near the horizon. If you want to reduce the yellow, use a light blue 82A filter, **right.**

No filter

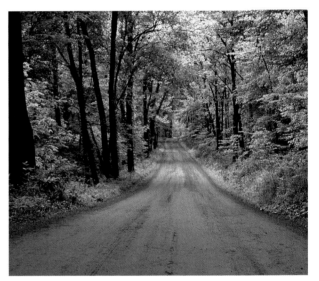

No. 8 yellow filter

You can alter the mood of any color picture by using a colored filter. Here a No. 8 yellow filter brightened up this forest road.

Filters for Color Films

In daylight color photography, filters hone the color balance of a picture. If you're using color negative film you can avoid much of the need for filters because the colors of negative films can be corrected in the printing stage.

Photographed with color slide film, scenes in shade, on overcast days, or at high altitudes can seem slightly too bluish. In the first two cases, the bluishness is there but unseen by the eye. At high altitudes, an abundance of ultraviolet radiation, invisible to the eye but not to film, further exaggerates the bluish tinge of slides. If at any

time you find the blue distasteful (not all people do), you can reduce it a touch with a UV (ultraviolet) filter or a skylight filter. You can further reduce or even eliminate it with an amber 81A, 81B, or 81C filter (listed in order of increasing density). The 81B filter is probably the best choice for nearly eliminating the bluish tinge without adding its own tinge of amber to the scene.

Conversely, the bluish 82 series filters absorb excess yellow light that occurs very early or very late on sunny days. Usually this warmish cast

is pleasing. It enhances the mood of a picture and helps relate the romance of this time of day. But it can also be a distraction when you desire accurate color reproduction.

Of course, you can also use filters from either series to exaggerate their colors of light. You might use an 82 series filter to dramatize the cool blueness of a snowy winter's eve, for instance. Or you might use a strongly colored filter to establish mood and override reality.

Haze Reduction

Haze can be a pesky problem. The haze you see consists of mainly blue light scattered by airborne particles and moisture. The haze you don't see is scattered ultraviolet radiation. Film can see it. So your pictures will seem even hazier than what you saw. Haze is the worst around large cities and in humid climates. The problem worsens when photographing distant scenes with long lenses, which further magnify the effects of haze.

With black-and-white film, you can attack haze with an arsenal of filters. With color film, your arsenal is ineffective. To reduce haze, you need a filter that blocks some of the scattered blue light and ultraviolet radiation. Because the filters that reduce haze are colored, they are of little use in color

photography but of much use in black-and-white photography. With black-and-white film, a No. 8 yellow filter has the least effect, showing scenes similarly to what you saw. The No. 15 deep yellow, No. 25 red, and No. 29 deep red filters progressively reduce haze and darken blue sky. The No. 11 yellowish-green, No. 58 green, and No. 61 deep green filters also reduce haze but offer an alternative in affecting other colors. For instance, if you didn't want the dark foliage tones caused by a No. 25 red filter, you could use a No. 58 green filter to lighten green foliage.

Some haze can increase the feeling of distance in a scene and is sometimes a desirable picture element. If you want to increase haziness, use a

No. 47 blue filter which increases the penetration of blue light.

You can also combat haze through film choice. The extra red sensitivity of KODAK Technical Pan Film enables it to penetrate haze better than other black-and-white films. Its extreme sharpness and fine-grain make it an excellent choice for landscape photography. The best film for reducing haze is KODAK High Speed Infrared Film used with a No. 25 red filter or a No. 87 filter. However, you wouldn't normally use this film just to fight haze, but rather for its surrealistic effects as explained in the film section.

In color, you can slightly reduce haze with a polarizing filter or a haze, ultraviolet (UV), or skylight filter. The effect, as illustrated, is slight.

No filter

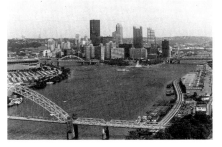

No. 25 red filter

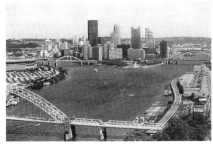

No. 47 blue filter

To reduce the appearance of haze and better render detail in distant scenes in black-and-white photography, use a dark yellow or red filter.

No filter

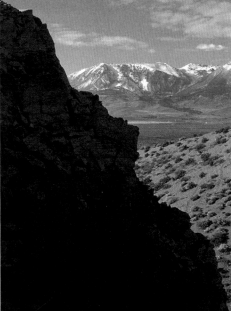

Polarizing filter

When taking color pictures, you can't always significantly reduce the appearance of haze. Your best weapon is a polarizing filter. Used at an angle of 90° to the sun it can reduce haze, as shown, as well as darken blue skies and increase color saturation. So-called haze filters offer only a slight reduction.

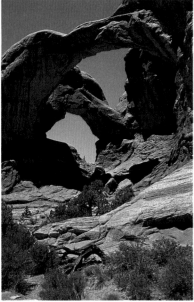

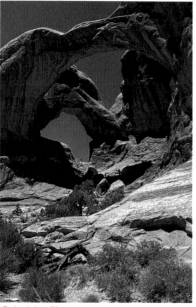

For this scene, using the polarizing filter not only darkened the blue sky, but it also reduced the surface reflections from the rocks to give them richer colors.

No filter

Polarizing filter

Here, the polarizing filter reduced reflections from the water and lily pads to give richer colors and increase the contrast.

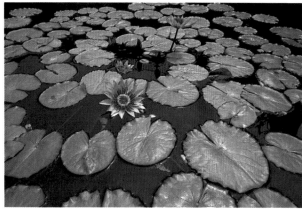

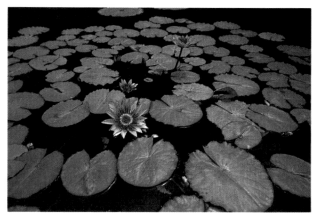

No filter

Polarizing filter

Polarizing Filters

If you had to limit yourself to owning just one accessory beyond camera and lens, a polarizing filter would have to get serious consideration. It is one of the few filters that works equally well with black-and-white or color films. You can use it to darken a pale blue sky, saturate colors, remove surface reflections, or reduce atmospheric haze.

You don't have to understand everything about how a polarizer works to use one, but having some idea of the general principle will help you know what it can and can't do. Rays of light always travel in straight lines. But the waves that make up those rays vibrate in many directions and angles at once. When a light ray strikes a reflective surface, however, it becomes polarized—that is, it vibrates only in a single plane.

A polarizing filter eliminates polarized light. In appearance a simple glass

disk in a rotating frame, the filter consists of rows of submicroscopic crystals arranged in parallel lines—like the pickets in a fence. Only light traveling parallel to the "pickets" is transmitted to the film. By rotating the filter, you can change the angle of the pickets until they block much of the polarized light in the scene.

Don't worry about understanding the theory. It's more important that you become familiar with the filter's results. By rotating the filter as you look through the viewfinder of an SLR, you can see its effect. As you rotate the disk or change your viewing position, it eliminates varying amounts of polarized light, thus altering the appearance of the scene.

The impact of a polarizer is most dramatic in darkening blue sky. Much of the light in the sky is polarized and can be erased with a polarizing filter. Haze erased, the sky darkens to a rich

blue and clouds ignite in their whiteness. The dark sky effect of the filter is least apparent near the sun and intensifies dramatically as you reach an angle 90 degrees to the sun. Again, as you rotate the filter, the effect will visibly increase or decrease. Unpolarized to polarized light forms a graded band in the sky. The band is usually wide enough so that normal and telephoto lenses capture a uniform part of it. However, a wide-angle lens can reveal so much of it that the gradation becomes obvious and distracting.

Perhaps equally important for landscape photographers, polarizing filters eat up the glare of myriad surface reflections, large and small, that dilute colors. Grasses glow in their greenness, roses resound in their redness and puddles, ponds, and lakes preen in their slick jet blackness. Again, the amount of color saturation you

achieve depends on how much polarized light you eliminate.

If the color saturation doesn't increase enough, try changing your viewpoint or angle slightly. When reducing reflections, a polarizer works best when you stand at an angle of about 35 degrees above or to the side of the subject's surface. When working with watery subjects, you may not want to eliminate all reflections. Their sheen can add a pleasing appearance. Rotate the filter on the lens and observe through the viewfinder its effect on the reflections. Stop when the reflections appear right to you.

Not all built-in meters can accurately measure light with a polarizing filter attached. Take a meter reading without the filter attached. Open up the lens 1½ stops. Attach the filter and meter the same area. If the meter indicates your exposure is correct, it probably reads accurately through a polarizer. If it can't, simply meter the scene before attaching the filter and open up 1½ stops. Then take the picture with the filter attached. Cameras with built-in meters that measure light actually hitting the film often require a special circular polarizing filter. Consult your camera manual about polarizing filters.

Graduated Filters

Here is a filter designed mainly for landscape photography. Half the filter is clear (colorless). The other half is colored. So that the color-clear border isn't obvious in photographs, the color density lessens as it nears the clear half of the filter.

You can use this filter to provide increased detail in midtone areas of high-contrast scenes or to add color and density to bald skies. After attaching it to the lens, align the colored part of the filter over the sky with the filter's border lined up to and hidden by the horizon. With the filter darkening the bright sky, often a sunset, you can give more exposure to the foreground without fear of washing out the sky. The result is a pleasing sky and extra detail in the foreground.

Tobacco, mauve, gray (neutral density) are some common colors of this filter. Determine exposure for the scene before attaching the filter. Meter from the important area of the scene—usually the foreground. Set that exposure on the camera. Attach the filter and take the picture.

The amount of polarized light in the sky continually increases until it reaches an angle of 90° to the sun. Photographed with a wide-angle lens and a polarizing filter, this area of polarized light may show up as a distracting gradation of increasingly darker blue light.

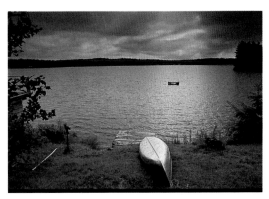

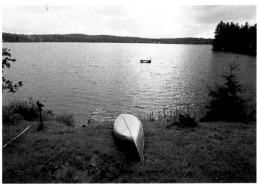

With a graduated filter, you can add color to bald skies without affecting the rest of the scene. As shown, graduated filters are available in a variety of colors.

The Seeds of a Personal Style

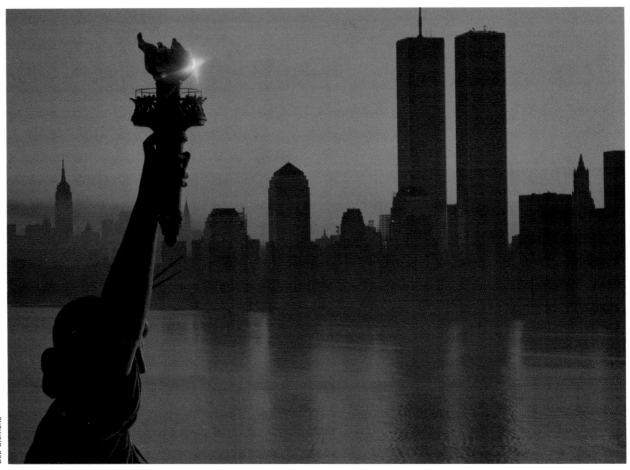

Bob Clemens

Kodak photographer Bob Clemens made this early morning photo from a helicopter. His 35 mm camera was mounted on a gyroscope for extra stability. The starburst was added in the darkroom.

Much of the material in this book has been devoted to the techniques and the theories of photographing the landscape—the specific skills required in making better pictures. But another area of equal importance, but less concerned with f/stops or lighting or camera angles and more concerned with ideas, is the matter of developing a personal style.

In the early stages of our photography, most of us are satisfied to come away with pictures that other people find interesting or entertaining. We've succeeded in sharing our vision with another person and we're grateful. Success is its own reward.

But at some point we reach a higher plateau of creative involvement and begin to confront the questions: Why am I taking pictures? What am I trying to say? Serious questions that

deserve serious consideration. To answer, we must begin to identify not only our feelings and opinions about the world around us, but our visual preferences and inclinations as well—these are the seeds of finding a personal style or approach.

There are probably as many different approaches to photographing the landscape as there are photographers. Set a dozen photographers loose in a given scene and they'll come away with a dozen different interpretations. Is one better than another? One right and another wrong? No more so than one good wine is better than another or Italian cooking is better than Creole. One way to discover the approach that's correct for you is to study the approaches of other photographers—which we'll do on the next few pages.

SOCIAL COMMENTARY

Though most of us use landscape photography as a way of remembering the more picturesque and pleasant aspects of the world around us, some feel compelled to seek out and document the mistreatment of our environment. Rather than look to the grandeur and the glory, they look to the dismal and the decaying, the forgotten and the forlorn. While others' eyes follow the sun setting over the Appalachian foothills, theirs scan the dirt roads and the tumble-down shacks at their feet.

Why would anyone intentionally seek out distasteful views? In some ways they may be after the same result as those who create idealized views. For example, although some seek to kindle our interest in preserving nature through inspiration, others try to rouse our attentions by show-

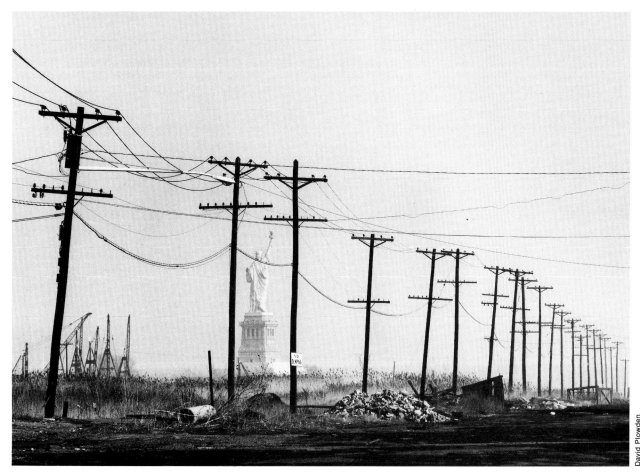

Taken from the Jersey City side of the Statue of Liberty more than a decade ago, this is not a view we could expect to find on fund-raising brochures or tourist guides.

ing us the destruction and waste wrought by abuse. In photographing the Hudson river laden with garbage or the Mojave desert scarred with tire tracks, they hope to awaken our instincts of preservation.

Not everyone who photographs the underside of the social landscape clings to an idealistic cause or a social mission. Some may merely find fascination in photographing a much ignored wealth of visual material. To them, such landscapes may not be distasteful but simply an intriguing accompaniment of civilization. Whatever the stimulus though, finding material for such explorations isn't difficult. Photographer David Plowden spends much of his time photographing the strange beauty of industrial landscapes, often focusing on the fading glory of the past. Using black-and-white film to preserve the stark shapes

and textures, he portrays many of his subjects with dignity.

There is a bittersweet beauty to be found in the shedded skins of a maturing society: The nostalgic romance of the abandoned drive-in theatres, the fading glory of boom town streets that once kindled the bright promise of prosperity and growth, and the rusting ring of industrial decay that encircles the edges of virtually all of our aging cities.

Then, too, there are those photographers who recognize a dark and ironic side to the institutions and symbols of progress associated with modern society: The eerie fluorescent glow of the all-night self-serve gas stations or the neon shimmer of a Las Vegas wedding chapel. This defiance of night and thus human nature is but one sign of the frenetic pace of civilized life.

A belch of smoke rudely and somewhat humorously interrupts this pastoral. Social commentary need not be heavy-handed or moralizing.

105

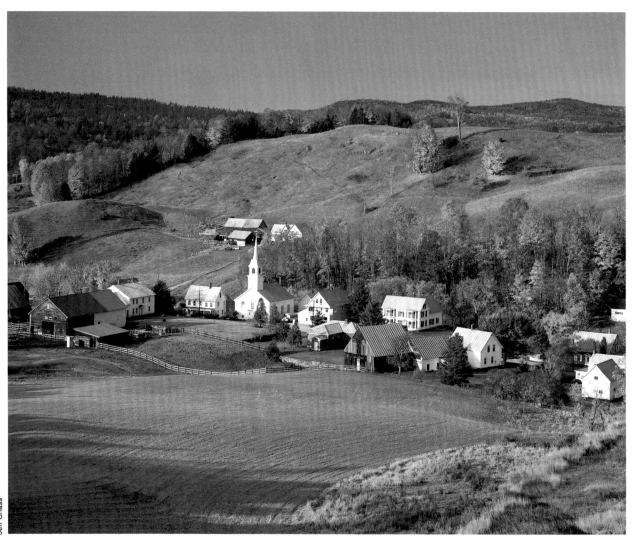

Jeffrey Gnass has made an idyllic portrait of the village of East Corinth, Vermont, nestled in the autumn hills. Sunny day, colorful foliage, whitewashed houses, picturesque steeple—all the elements a chamber of commerce could ever want are shown.

THE GLORIFIED VIEW

Far and away, the most popular style of landscape photography is the glorified view. It depicts dramatic subjects, often from dramatic viewpoints. Its spiritual roots reach back to the 1800's. Then, William Henry Jackson, Carleton Watkins, and others trudged through the West encumbered by view cameras, glass plates, and accompanying chemicals for coating plates and developing them. Some of their photographs of Yosemite and Yellowstone helped convince a Congress 3,000 miles away to preserve these areas as national parks.

Although there's less and less of it, wild, untouched nature (or the appearance of it) is avidly sought by landscape photographers. They seek it not only to photograph it but to be a part of it. They seek it not so much for inspiration but for spiritual fulfillment, to commune with what is glorious and godlike on earth. Eventually, though, they must fold their tripods. Once home, only the photographs can transport them back to their communion with nature.

Finding an inspirational scene to direct the camera at does not often produce an inspirational photograph. It may produce a pretty picture or more likely a banal likeness. The glorified view of nature arrives after ruthless selection and exclusion. Dramatic lighting, weather, and flora are included. Negative references or distractions are excluded. Ansel Adams' portraits of Yosemite Valley reveal a pristine wilderness of unparalleled drama and

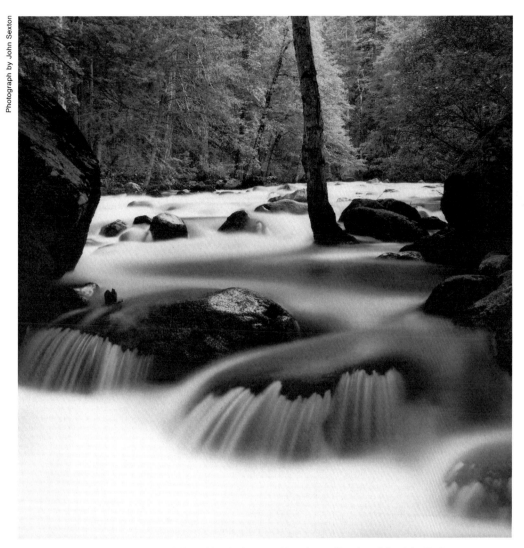

This view of the Merced River is reinforced by the impeccable print quality given it by John Sexton.

beauty. To arrive at Yosemite in person, however, is to find reality. Shoulder to shoulder, bumper to bumper, camera to camera, over 3,000,000 tourists yearly jostle on trails and at overlooks to experience wilderness. Adams invariably excluded references to the human presence. He enhanced the sanctity of his subjects in others ways as well: by waiting on the dramatic and exuberant moods of already grand subjects; and by using the highest levels of craftsmanship to embellish every nuance and detail of those moods.

But nature is not the only subject to be rhapsodized by the selective vision of the camera. Other landscape photographers strive to show us familiar aspects of the human environ-

ment in a similarly glamorous light. Photographer Joel Meyerowitz's large-format color photographs of Cape Cod, for example, make careful use of the soft, hypnotic sea light and elegant, muted colors to reveal a dreamy portrait of such mundane subjects as beaches and cottages and front porches. Meyerowitz describes his subjects as "ordinary" but the images themselves as "contemplative, almost symphonic."

Whatever the subject, the grandness of nature or the familiar haunts of everyday life, it's much easier to idealize a subject that you feel a special kinship for and that you want to share with the world. You can fake a lot of things in photography, but it's hard to fake feeling.

So-called realistic landscapes often include mundane subjects, such as street intersections, composed in an eye-catching manner. Chip Pankey prints his black-and-white negatives using a platinum-palladium process that gives his prints a warm and rich appearance.

REALISM

Some photographers seek only to document. No editorial comments, no manipulations, no overt investigations—the world is recorded as found. For these photographers, the camera is used to do what it does best: record everything it sees in dazzling detail and with equal emphasis.

Although true objectivity does not exist, the obvious slanted view can be squelched. However, even with pretensions set aside, the photographer must select a subject, a viewpoint, and a time of day. Such choices reflect subjectivity. But if the photographer has avoided the obvious slanted view, then what remains will have the appearance of objectivity. He will have lifted the shade for you to look out.

Sterile, structured, devoid of emotion, such an approach might, at first glance, seem like the least effective of all possible choices. But what strength such pictures may lose in mood or atmosphere, they regain in their apparent honesty—an honesty open to a catalog of interpretations. By allowing reality to reach the film by the path of least interference, you offer the least tampered with vision of the world.

The photographer in effect steps aside to let us look directly through his viewfinder, and asks us to bring our imaginations to his images. Each of us is left to make our own subjective decisions about a particular scene, based on our own experiences. We

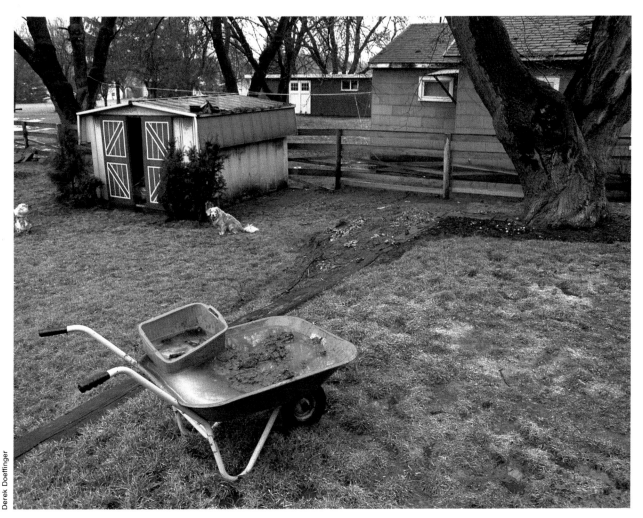

In our minds, winter is a sparkling stream running through a forest garlanded with freshly fallen snow, with all sparkling in the sunshine. The reality often differs. Shown here is the squalor of a mid-winter thaw in a backyard. The abandoned, ice-filled wheelbarrow in the foreground and the melted snowman, dog, and shed in the background set the scene.

get from the pictures what we bring to them.

Although the subjects of such starkly simplistic scenes often seem randomly or arbitrarily chosen, they are frequently the product of an acute sense of place and a peaked awareness of universal themes and subjects. The scenes chosen have their own form of idealness. Photographer Chip Pankey consciously seeks out the familiar places that most of us ignore—the sidewalks, intersections, backyards, and supermarkets that have become all but invisible to most of us.

Such images seem simple to make. Don't be fooled. What may appear to be utter simplicity often takes excruciating patience and care to create—try

it sometime and see. The best places to look for potential subjects are in your own neighborhood, where your familiarity gives you an edge in seeing simply.

But don't be too disappointed if your pictures meet with negative or mixed reaction. Many people simply turn off their receptivity when confronted by realistic views, finding them banal or lifeless, or even troubling. Even when well done, such photographs may require more effort to appreciate than many viewers are willing to provide. After all, there are lots of pretty and interesting photographs that ask only to be enjoyed— no interpretation or introspection required.

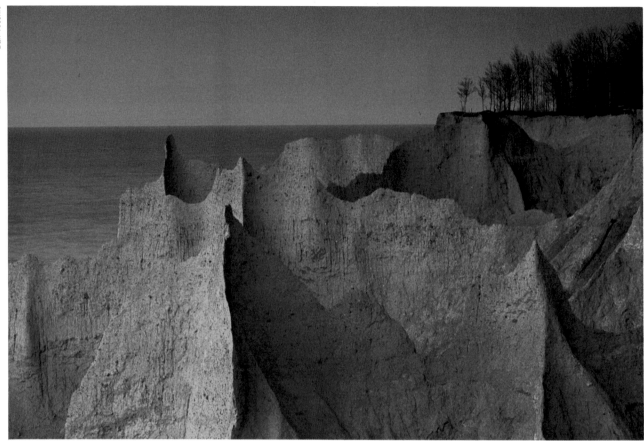

The sinuous curves of eroded cliffs, a scalp of trees, and a slip of water form this haunting scene along Lake Ontario. The photographer used KODAK EKTACHROME Infrared Film and a yellow filter.

ABSTRACTION

For many photographers, beauty and drama lie not in literal interpretations of their subjects, but in their inherent design. Reality is but a springboard for their imaginations, a challenge to their designer's instinct. Rather than embellish or preserve the world as most of us see it, they seek out a seldom seen landscape of form, shape, color, and texture—a world where design rules.

While it may be easy for critics to dismiss such images as imaginative wanderings, handled well, abstraction charms. Without the intrinsic interest that a recognizable subject brings to an image, the success of an abstract photograph hinges on the photographer's ability to create pleasing or interesting visual arrangements from the barest of design elements.

Subjects for abstraction exist everywhere: The hard angles, shiny surfaces, and bold shapes and lines of modern architecture, or the textures, patterns, and colorations of nature. The trick in finding potential designs lies in learning to see beyond face value, to penetrate past familiar facades, to explore beyond the obvious. And equally important, is having the courage to accept the risks of looking at the world through unconventional eyes—and in knowing that your explorations of such uncharted horizons may go unwelcomed, that the response may be a shrug of the shoulders instead of a clap on the back.

Because creating abstractions is such an intimate form of self expression, each photographer will approach the process differently. To uncover the essence of a place, pare it to the minimal visual ingredients. Rely on isolated zones of shape and color to evoke the spirit—but not the specifics—of a place. Italian photographer Franco Fontana is a master of such work, frequently reducing landscapes to a few distinct bands of color.

Another method is to exploit unusual shooting angles and vantage points: Gary Braasch, whose photo is shown here, is another photographer who can see beyond a landscape's obvious features. Lie on the ground to see the jigsaw geometrics of a fire escape, or shoot down from a hotel balcony to catch the colorful parade of cafe awnings. Shadows and reflections supply abstract patterns—rippled reflections of a city street in the face a mirrored building, for instance.

However you approach abstraction, and whether you use it as an occasional escape from the sameness of day-to-day reality or as a serious artistic pursuit, the challenge involved in leaving your preconceived impressions of reality and beauty behind is a stimulating experience for both the eye and the imagination.

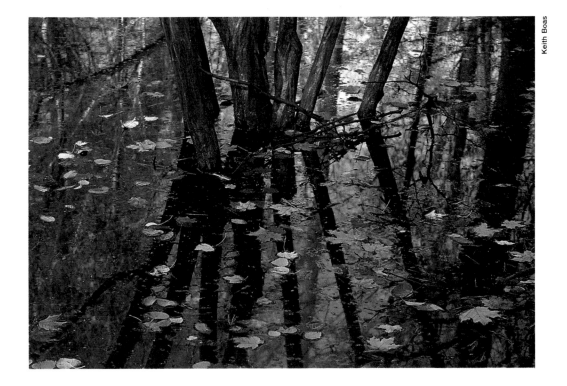

Top photo, the reflections of water often make for good abstracts. The shapes of the leaves scattered across the water's surface break the symmetry of the reflection. **Bottom photo,** tree limbs radiating like ganglions, dark windows, and the shattered outline of a building combine to form a vaguely menacing abstract.